ELEVEN || CONTACT PRESS IMAGES

WITNESSING THE WORLD TRADE CENTER 1974–2001 EDITED BY ROBERT PLEDGE **ELEVEN** ‖ CONTACT PRESS IMAGES

UNIVERSE

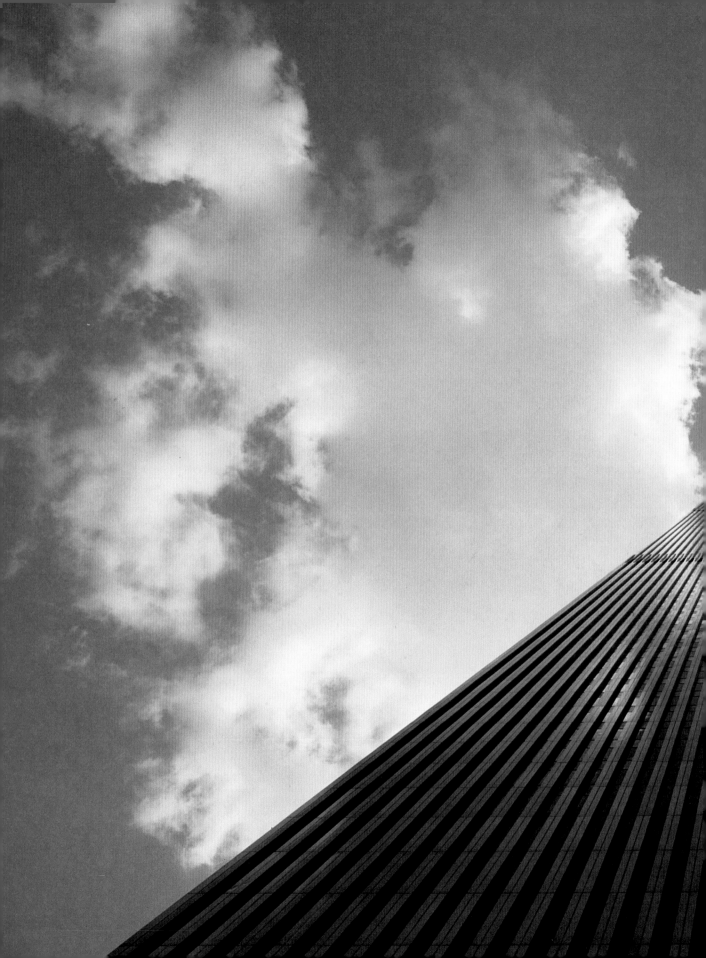

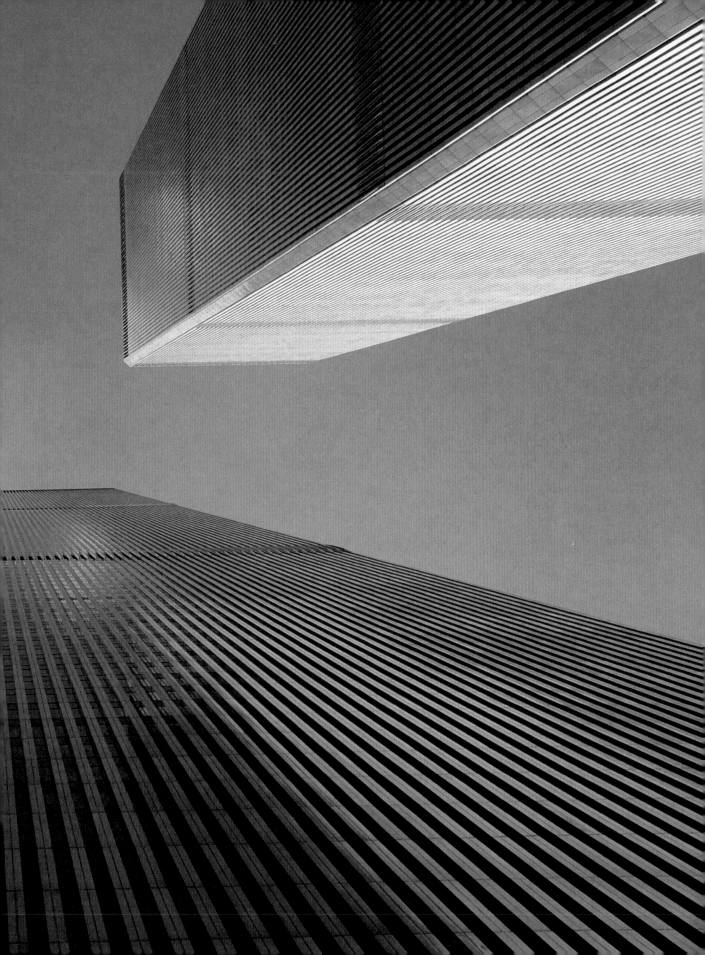

FIRST PUBLISHED IN THE UNITED STATES
OF AMERICA IN 2002 BY UNIVERSE PUBLISHING
A DIVISION OF RIZZOLI INTERNATIONAL PUBLICATIONS, INC.

300 PARK AVENUE SOUTH
NEW YORK, NY 10010

2002 2003 2004 2005 2006 / 10 9 8 7 6 5 4 3 2 1

PRINTED IN THE UNITED STATES OF AMERICA

LIBRARY OF CONGRESS CONTROL NUMBER: 2002108062

EDITED BY ROBERT PLEDGE
TEXT BY JACQUES MENASCHE

CONTENTS

PHOTOGRAPHS BY:
JANE EVELYN ATWOOD
ZANA BRISKI
DAVID BURNETT
ADGER W. COWANS
DEBORAH EDELSTEIN
CHUCK FISHMAN
FRANK FOURNIER
FRED GEORGE
GIANFRANCO GORGONI
LORI GRINKER
HALE GURLAND
SEAN HEMMERLE
KENNETH JARECKE
PETER B. KAPLAN
JAMES KEYSER
ANNIE LEIBOVITZ
VINCENT LOPRETO
TIM MAPP
DILIP MEHTA
ALON REININGER
FUYONG ZHANG
TIM ZIELENBACH

ELEVEN

SEPTEMBER 11, 2001. A SPECTACULAR MORNING. 72 DEGREES, CLOUDLESS. THE AIR CRISP, CLEAN. A BLUE STEEL SKY, PERFECT FOR BOLD ARCHITECTURE, FOR SHOWING OFF THE BRAZEN LINES OF NEW YORK CITY'S MODERN APOGEE, THE STREAKING EXPLOSION OF THE SIXTIES, THE SPIRITED GUST THAT BLEW THE JFK AIRPORT TERMINAL INTO ITS LOW-SLUNG TAKEOFF SWEEP—BUT MOSTLY, A DAY MADE FOR THE SLEEK, METAL GLASS HEAVEN-TOUCHING SPIRES OF THE TWIN TOWERS.

FROM EIGHT BLOCKS NORTH, AT THE CORNER OF HARRISON AND GREENWICH, A SOUTHWARD GLANCE OFFERS UP THE FULL VISTA OF THEIR PROUD ELEGANCE, THE EYE DRAWN DOWN INTO A THICKENING CANYON OF BUILDINGS, AT THE HORIZON, THE SPACE BETWEEN THEM BISECTED BY THE SILVER TOWERS SOARING UP, UP, UP, SO CLEAN, SO STARK, THEY SEEM TO HAVE BEEN CUT OUT OF A MAGAZINE AND PASTED ON THE SKY.

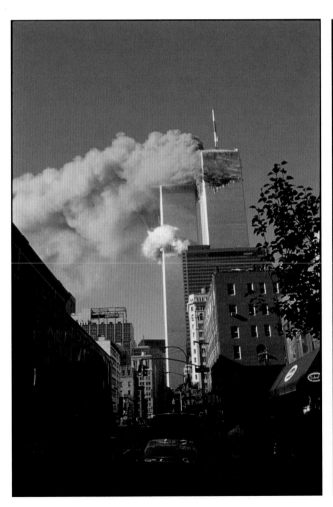
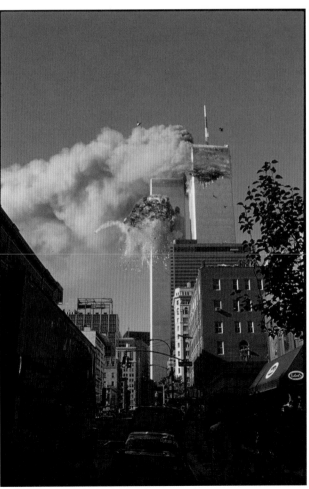

IT HAPPENS QUICKLY. LATER—*AFTER*—TIME WILL BEND AND TWIST LIKE THE WRECKAGE ITSELF: SECONDS BECOMING MINUTES, MINUTES SECONDS, AND HOURS SWEPT AND SNAPPED INTO DIFFERENT TIME SIGNATURES LIKE MODERN JAZZ. BUT IN THAT FIRST INSTANT, IT'S FAST. THE CRACK OF A SONIC BOOM. A SPEEDING BLACK PROJECTILE. AN ENRAGED ROAR OF EXPLOSION. AN ORANGE PLUME BURSTING FROM THE GLASS FACE OF WORLD TRADE CENTER ONE LIKE A CARNATION BLOSSOM—A BLOOM THAT GROWS SLOWLY INTO ITS FULLNESS, THEN PASSES OUT OF THE WORLD LIKE AN EXPIRED BREATH. ONLY AFTER THE BLOOM DEPLETES ITSELF, WHEN THE GAPING WOUND IN THE TOWER BEGINS TO BELCH UGLY BLACK SMOKE, DOES WHAT JUST HAPPENED BECOME CLEAR. "THEY BLEW IT UP!" SOMEONE SHOUTS.

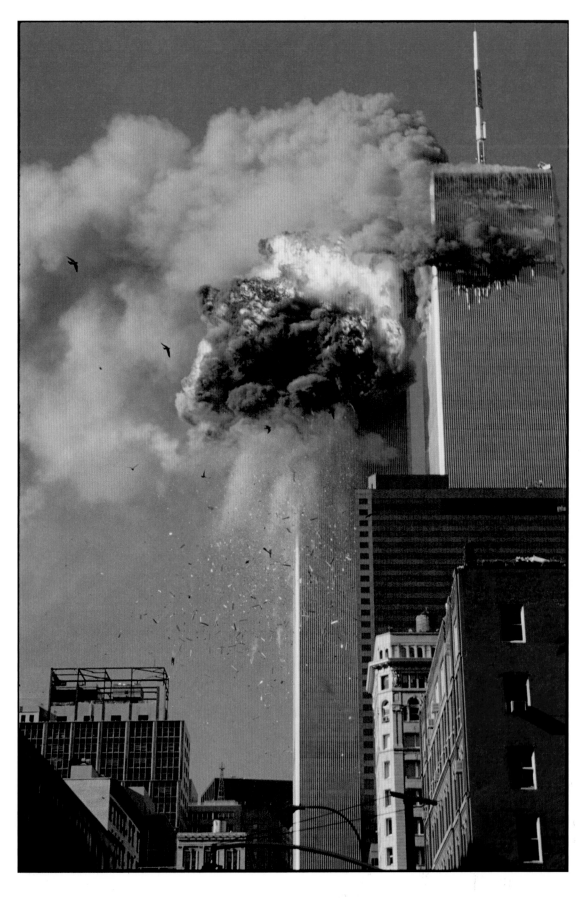

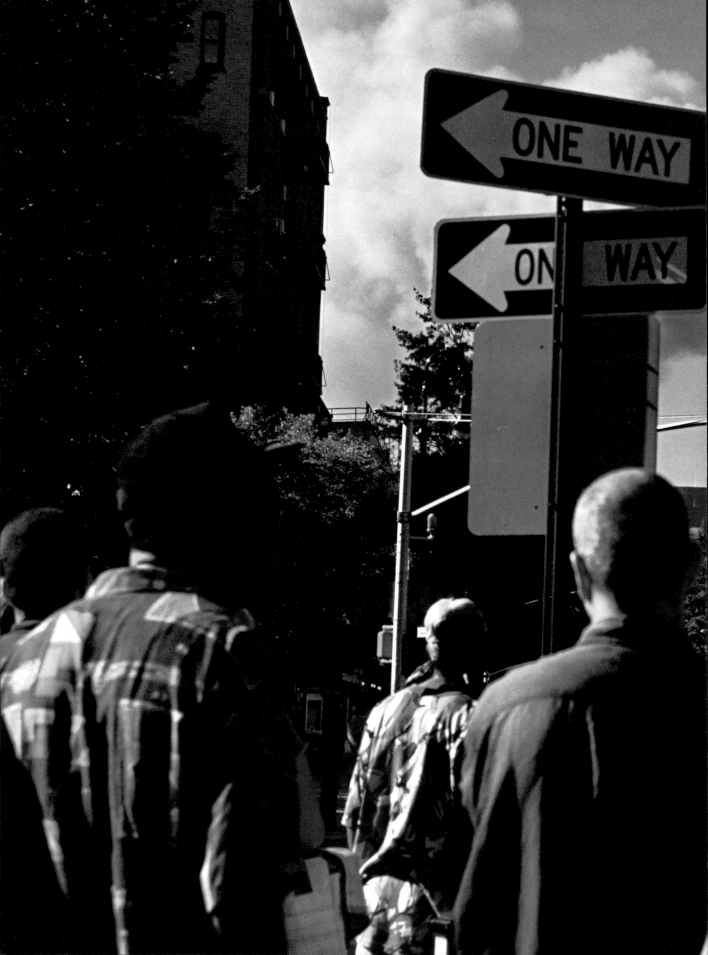

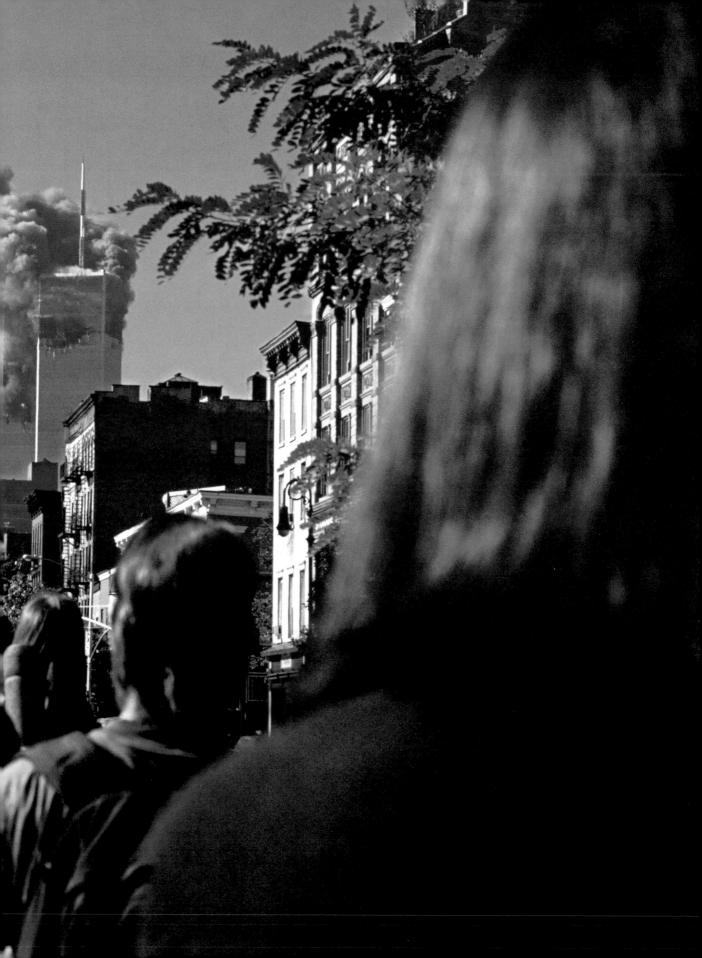

THEN THE SECOND ATTACK. AT FIRST IT SEEMS CHRONOLOGICALLY, AND IN TERMS OF HEIGHT AND FORCE, SECOND-ARY, LESS SEVERE—BUT THAT'S WHEN EMOTIONS BECOME UNHINGED. A SECOND BLAST CAN'T HELP BUT IMPLY THE POSSI-BILITY OF A THIRD, A FOURTH…A TERRI-BLE UNKNOWN YOWLING OPEN, THE MIND NO LONGER TRYING TO FOLD THE EVENT INTO ITSELF, TO CONFINE IT, BUT RELEASING HOLD OF ITS SANITY TO CONFRONT THE IDEA THAT *ANYTHING MIGHT HAPPEN*.

PEOPLE BEGIN TO LEAP FROM THE RIGHT SIDE OF THE BURNING TOWER. BLACK SILHOUETTES TUMBLING OFF THE STEEL SIDE OF THE STRUCTURE AND RAINING THROUGH THE BUILDING'S SILVERY TIARA OF DEBRIS. ONE AFTER ANOTHER, SEPARAT-ED BY INCONSTANT GAPS: SHORT, LONG, LONG, SHORT—A GRISLY MORSE CODE.

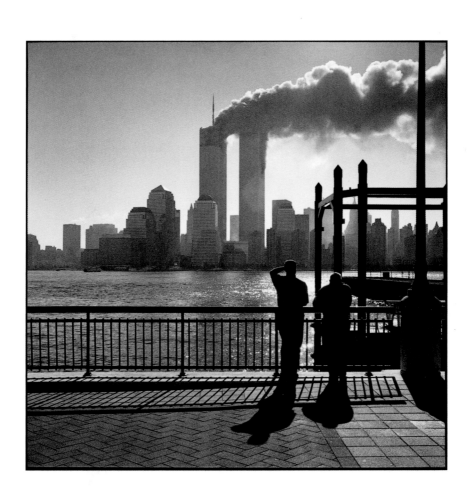

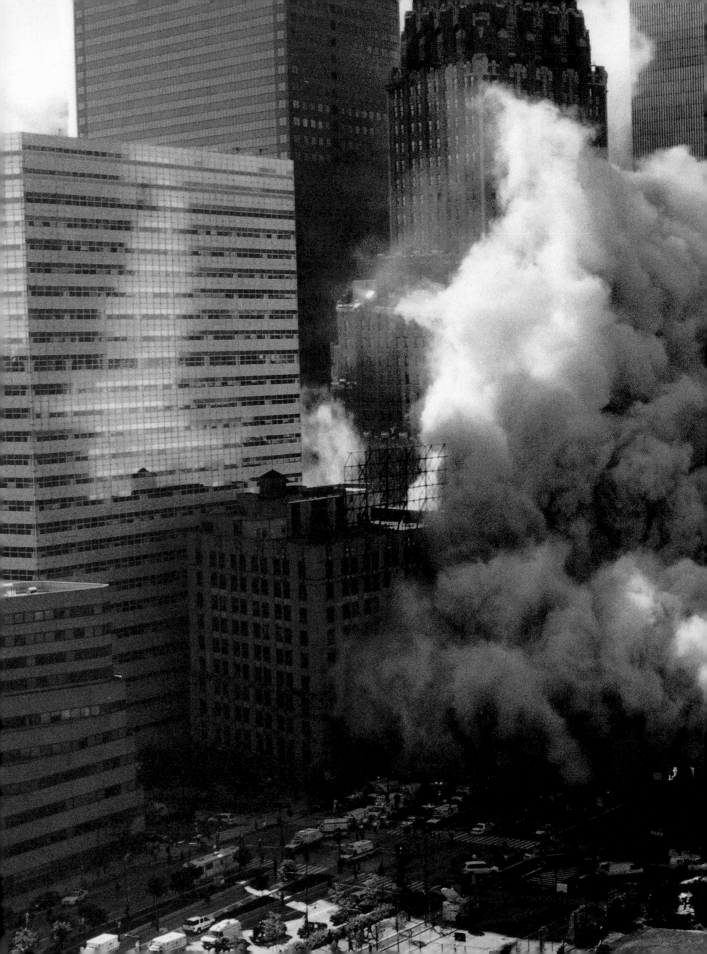

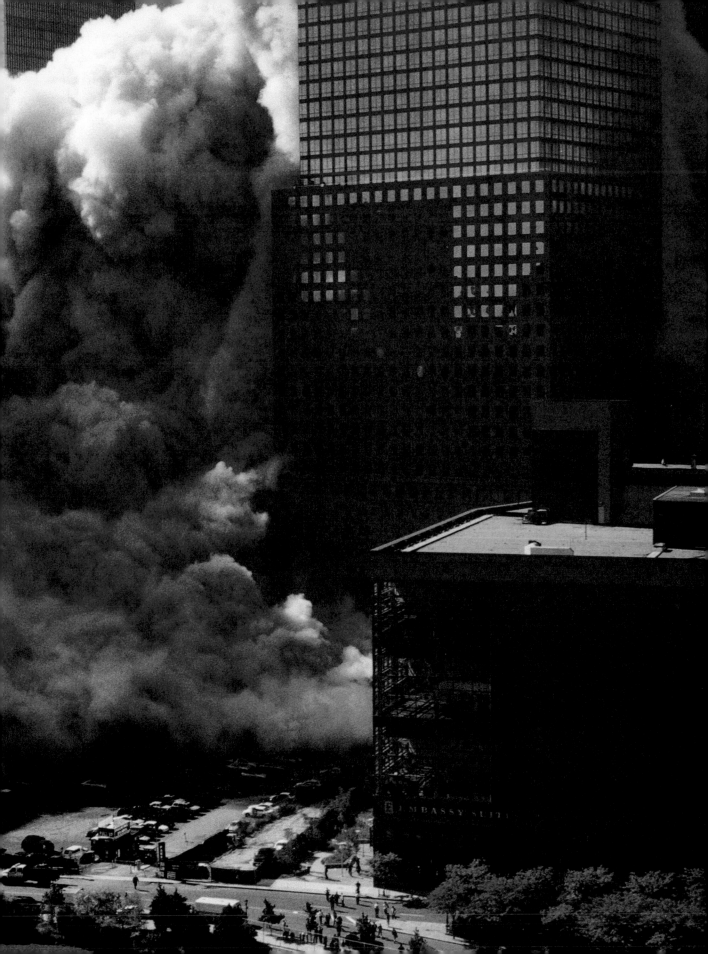

THEN THE SOUTH TOWER MELTS INTO THE EARTH. JUST DISAPPEARS. THOUSANDS OF BODIES REFLEXIVELY LURCH FORWARD, MIMICKING THE COLLAPSE, AND A TREMENDOUS GROAN GOES UP, THE SOUND OF AIR SUCKED FROM A THOUSAND LUNGS. GREENWICH STREET BECOMES A ONE-WAY THOROUGHFARE, A STREET OF EXODUS. IN EVERY DIRECTION, PEOPLE, POLICE CARS, SIRENS. A QUICK MARCH. PANIC BARELY HELD DOWN.

THE CROWD STREAMS NORTHWARD, SOME CRYING, OTHERS LAUGHING, TELLING JOKES, STILL OTHERS WITH STEREOTYPICAL NEW YORKER APLOMB, AS IF TO SAY "WELL, THAT'S THE BIG APPLE." PRIDE MINGLED WITH IDIOCY. A CRUSH OF BODIES, CELL PHONES, EACH WITH THEIR OWN PERSONAL RESPONSE, A CRUSH OF EMOTIONS, AN EMOTIONAL BABEL, THE FIRST SUGGESTION OF HELL AS DANTE MIGHT HAVE SEEN IT—AN ENDLESS PARADE OF DISPARITY, A NIGHTMARE OF DIVERSITY.

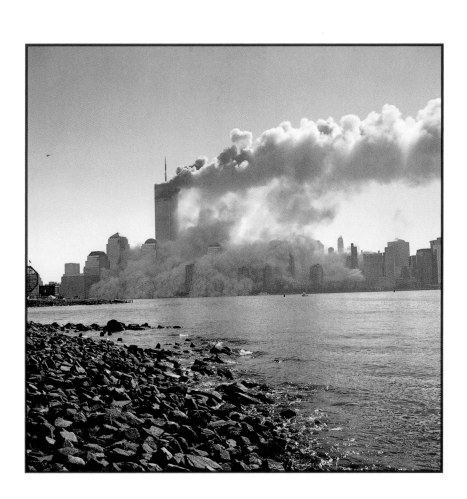

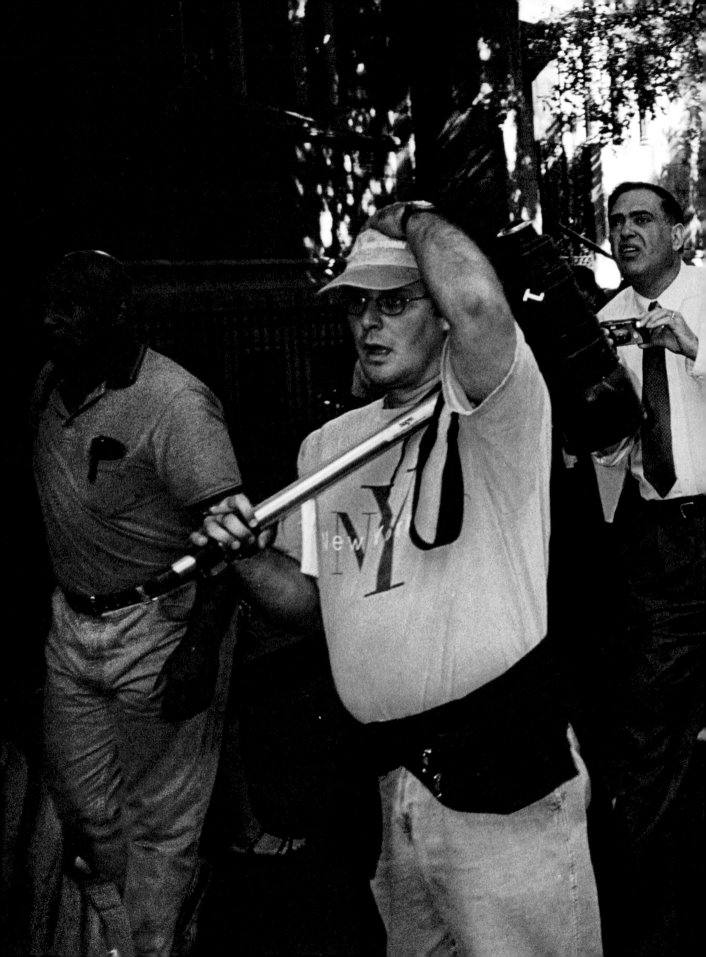

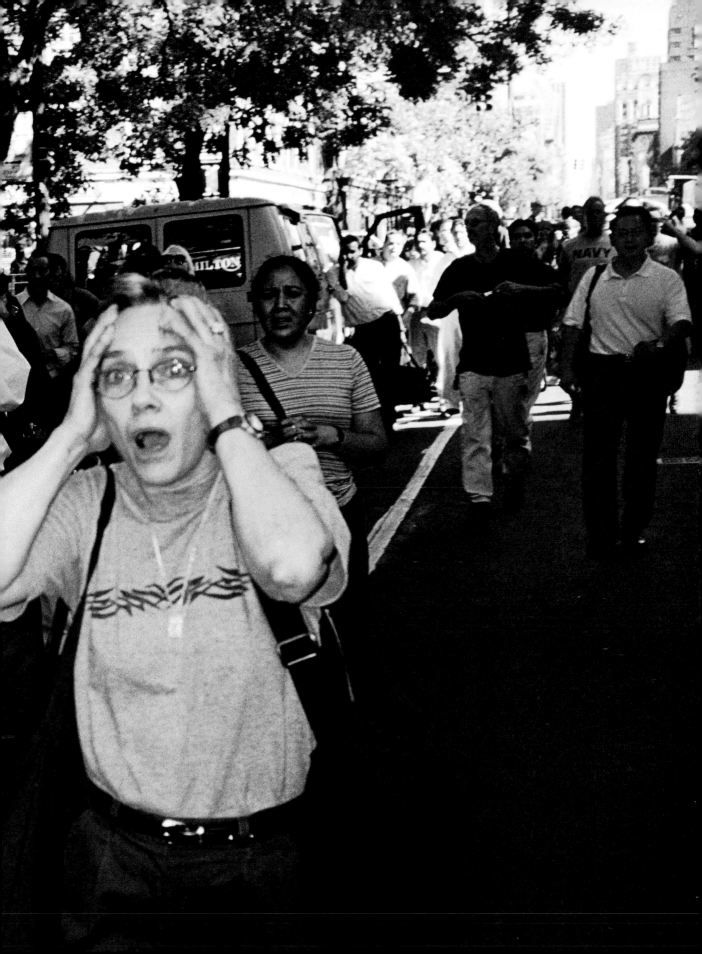

SUDDENLY CAMERAS—VIDEO, DIGITAL, POINT-AND-SHOOT—ARE EVERYWHERE. ONE YOUNG WOMAN, FACE PUFFED INTO A RED BALL, WALKS ABOUT IN A DAZE WITH A LEICA TAKING PHOTOS AND CRYING AT THE SAME TIME. SHE SUGGESTS A SUR-REAL ADVERTISEMENT FOR THE CAMERA—"LEICA: OUR PHOTOGRAPHERS CRY."

ASH-ANOINTED SURVIVORS STAGGER OUT FROM BUILDINGS AND FROM UNDER CARS, APOSTLES OF THE DISASTER. EVERY BLOCK MATTERS NOW. WARREN INSTEAD OF DUANE, CHAMBERS RATHER THAN BARCLAY—EVERY BLOCK, EVERY HUN-DRED YARDS, IS CRUCIAL. IN MINUTES, THE CITY HAS BEEN MAPPED WITH RINGS OF DUST. RINGS SEPARATING SURVIVORS FROM SPECTATORS, RINGS BLOWN BY THE WIND OFF THE HUDSON RIVER, A SACRED TOPOGRAPHY.

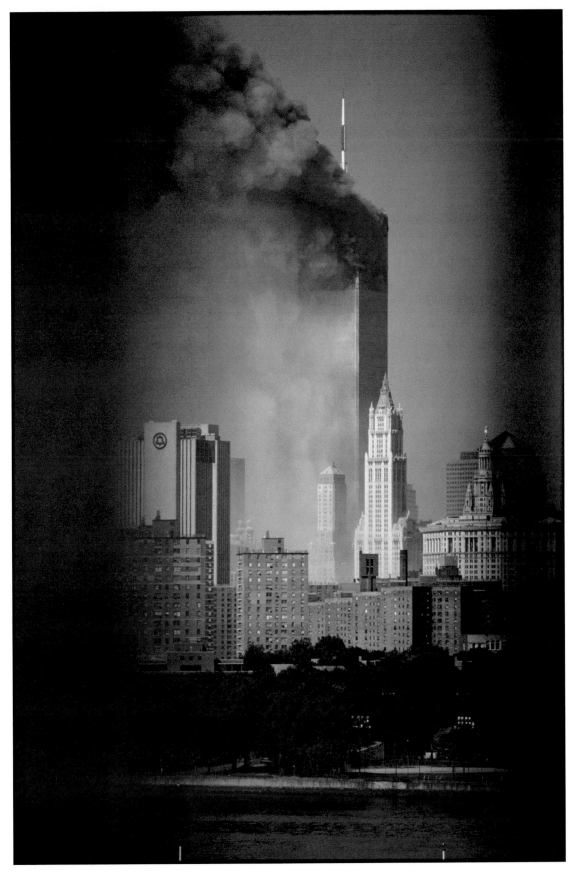

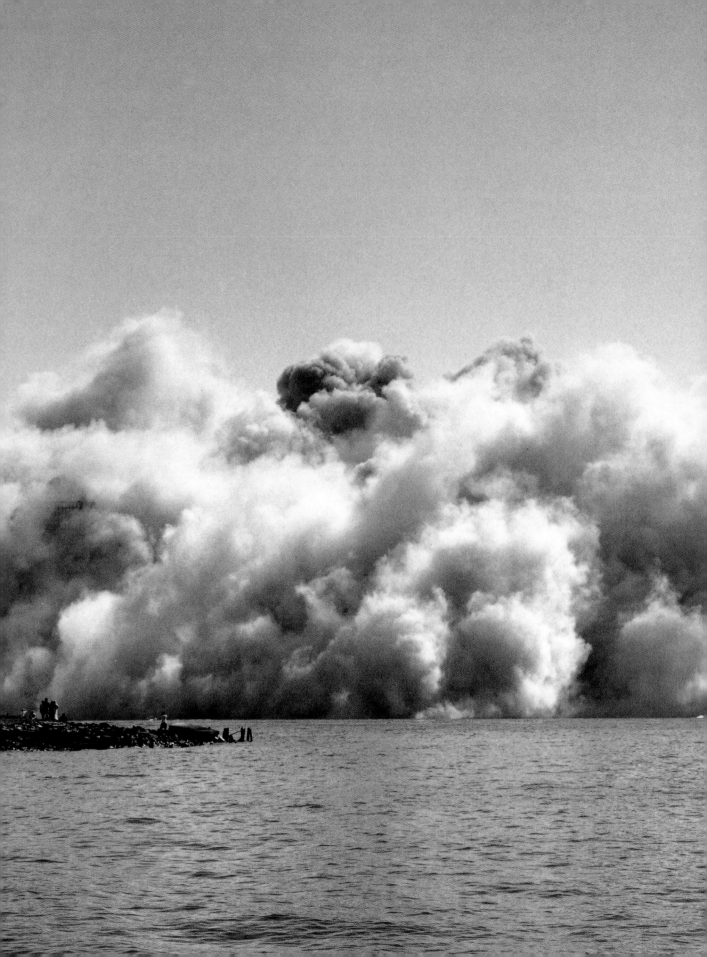

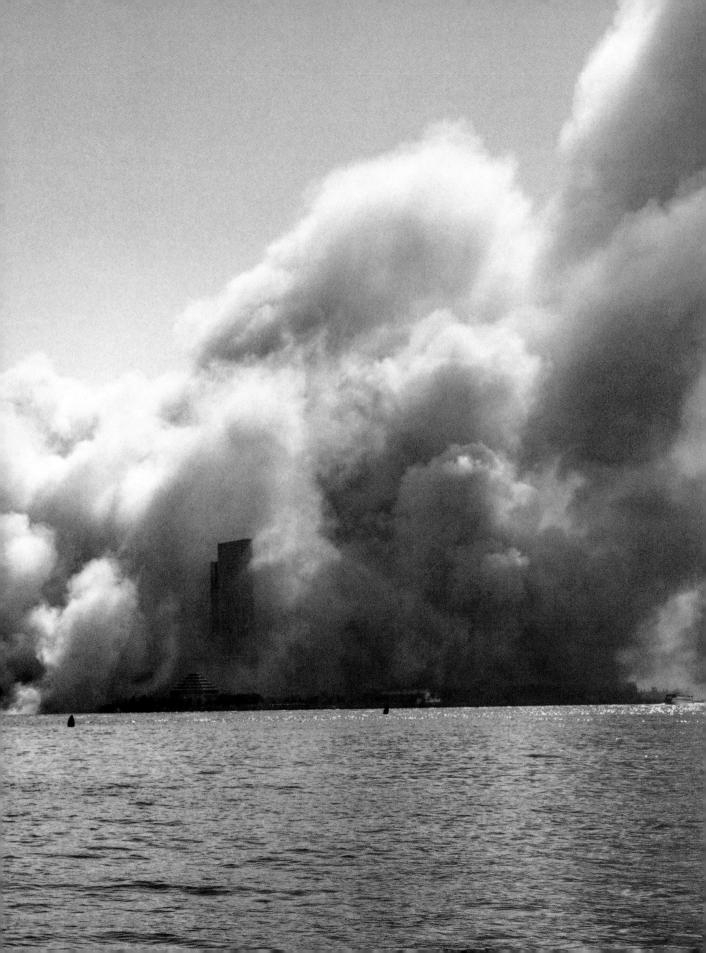

AT CITY HALL. THE STREETS TURN GRAY, THE PARK COVERED WITH A SNOW OF SOOT AND SHREDDED PAPER. THE CANYON OF HEROES LOOKS LIKE A MACABRE TICKER-TAPE PARADE ON THE MORNING AFTER. AT BROADWAY AND LIBERTY, IT'S DARK, THE AIR THICK WITH SMOKE AND AN ACRID STENCH OF BURNING. ALL AROUND A SOOTY, WASTED, SMOLDERING WORLD, THE STREETS DESERTED, ONLY LOST SOULS IN WHITE SURGICAL MASKS SCUTTLING OVER THE VOLCANIC SPEW OF ASH AND ATM RECEIPTS, KICKING UP CLOUD TRAILS OF DUST. A YOUNG COUPLE MOVES PURPOSELESSLY SOUTH. A WOMAN EMERGES FROM A GARGANTUAN OFFICE BUILDING, THEN FUMBLES WITH THE FRONT DOOR, THE LAST TO LEAVE, LOCKING UP BEHIND HER AS IF IT WAS HER HOUSE.

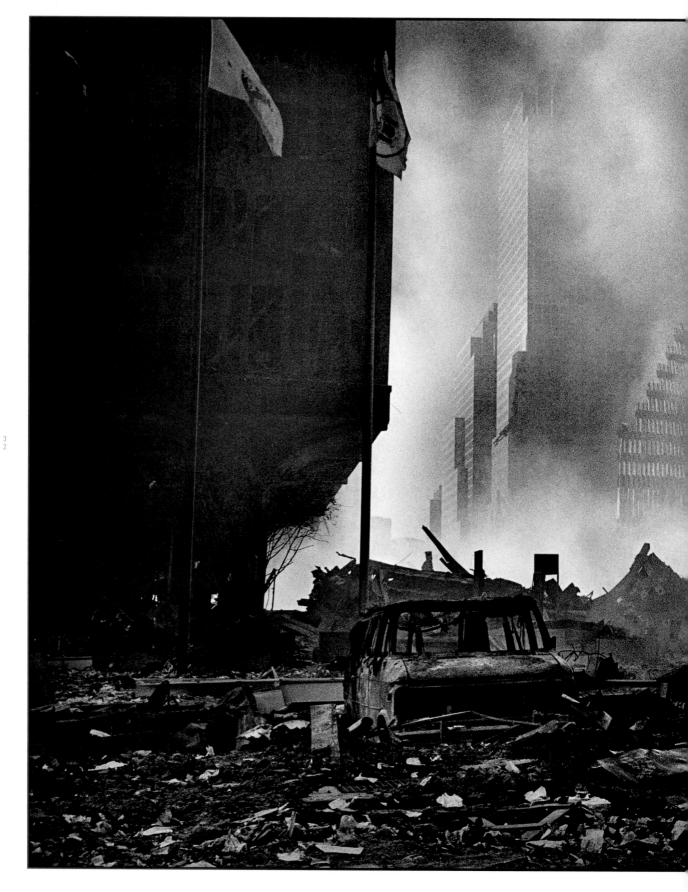

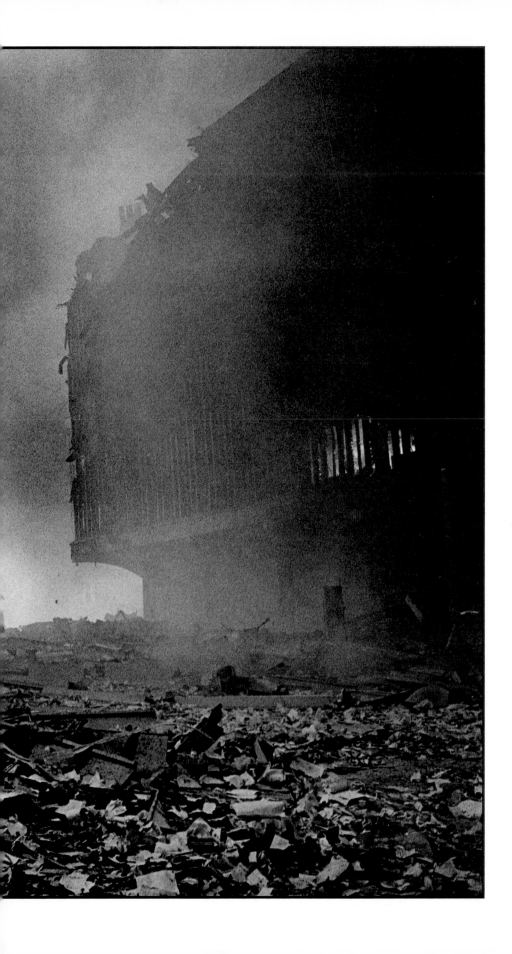

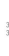

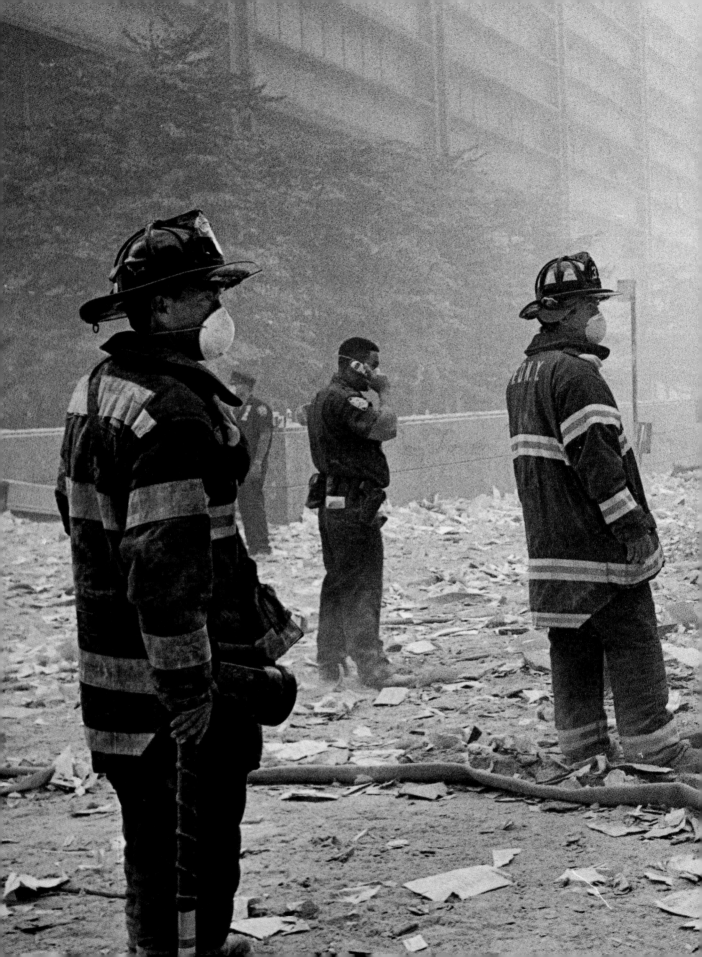

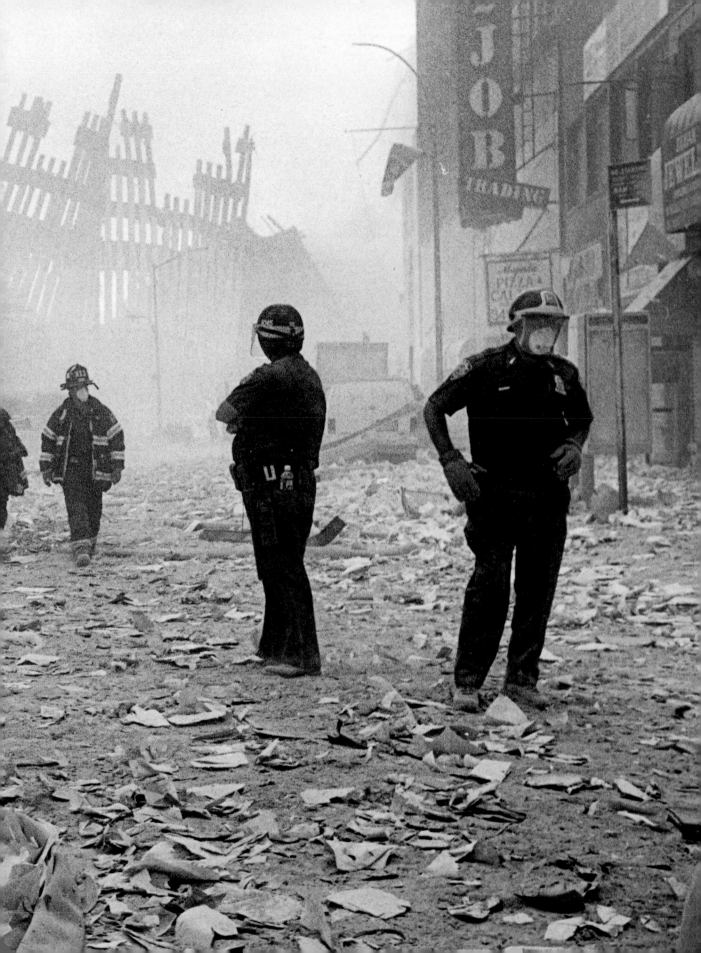

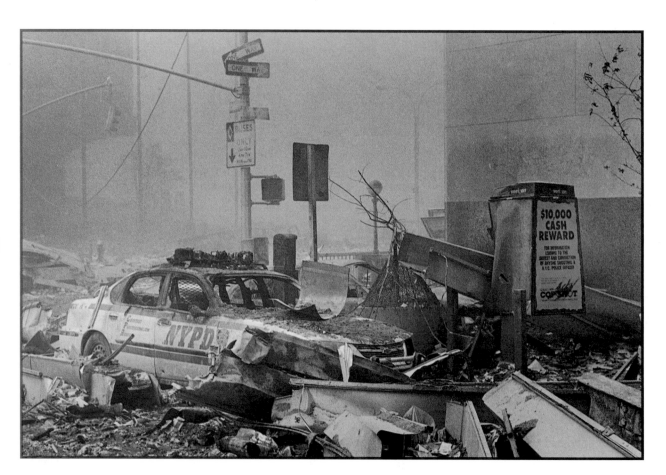

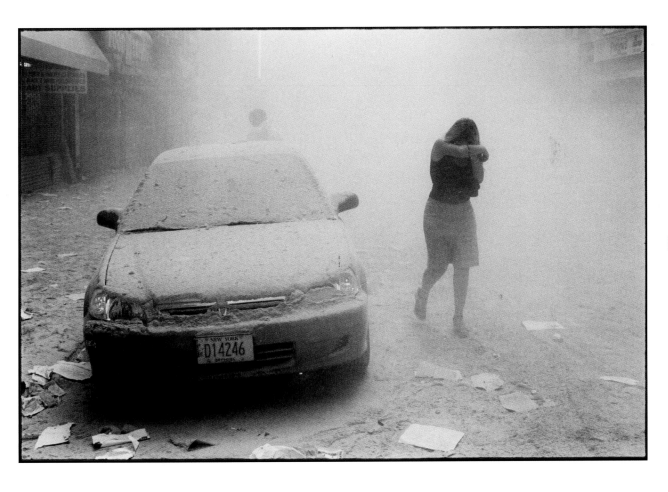

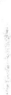

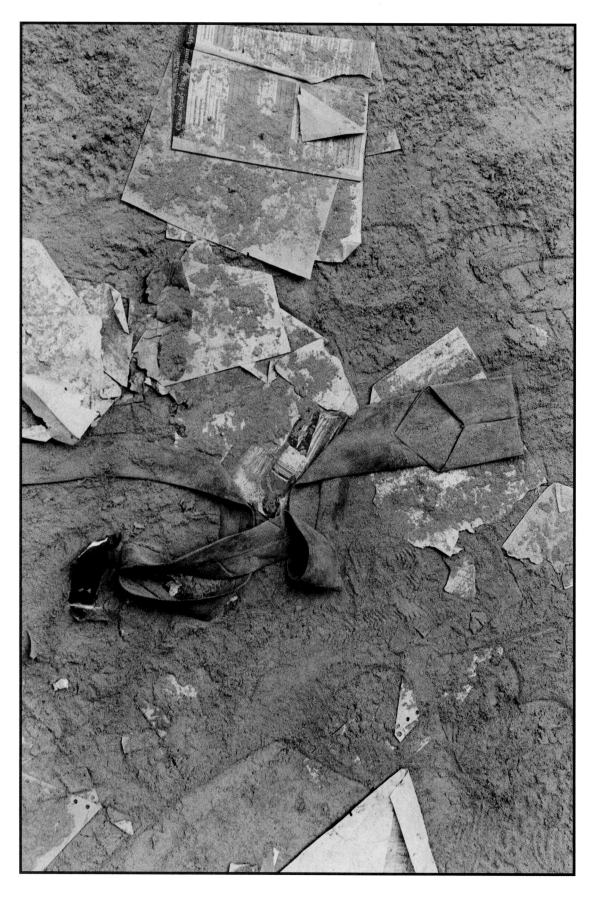

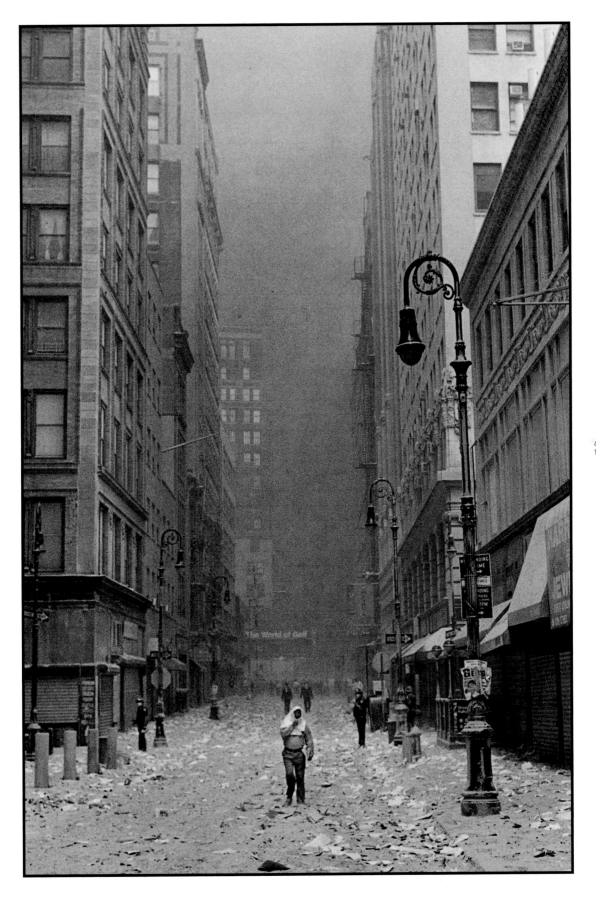

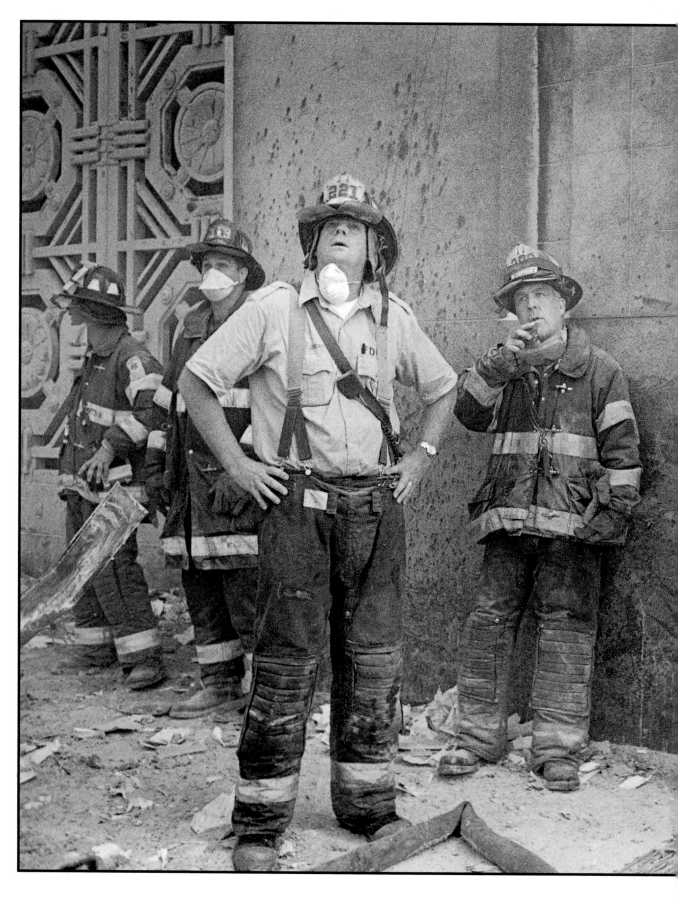

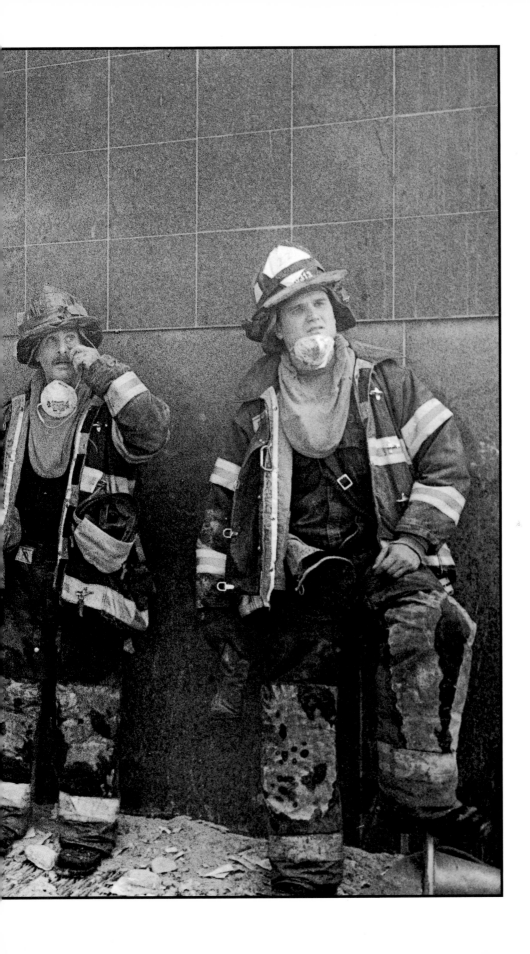

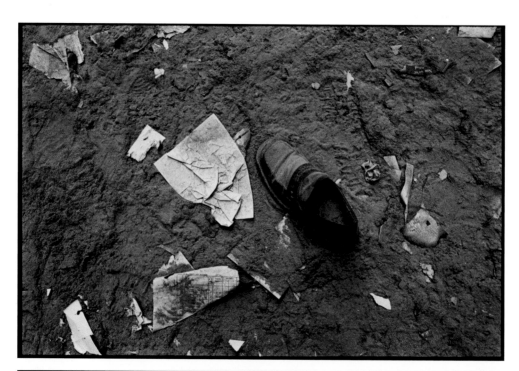

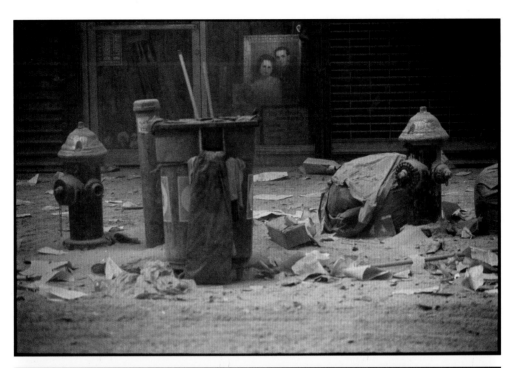

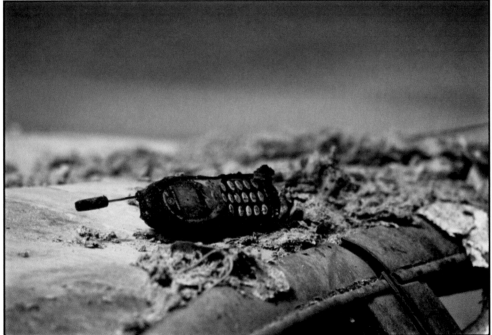

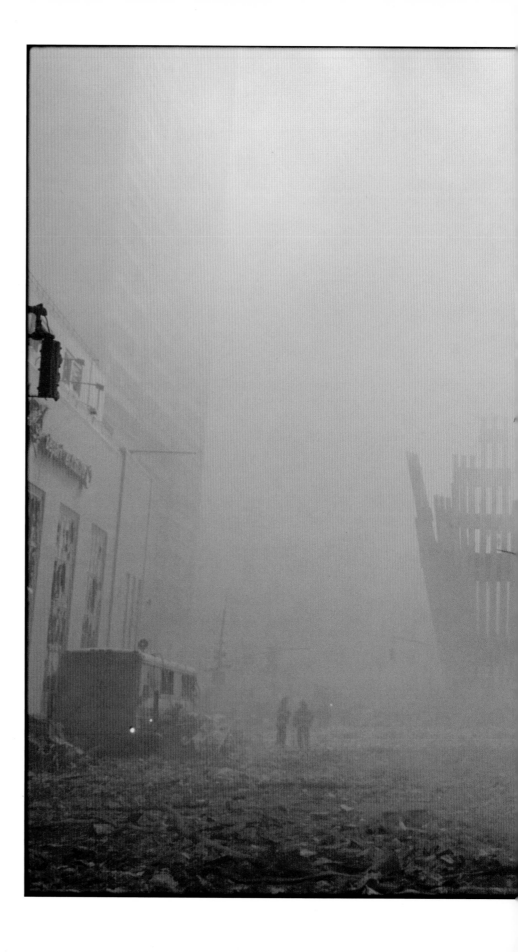

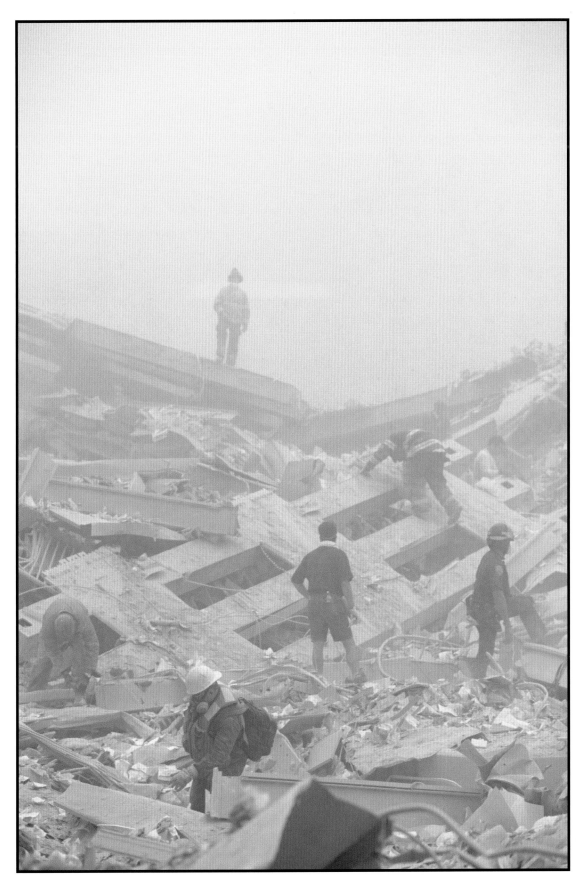

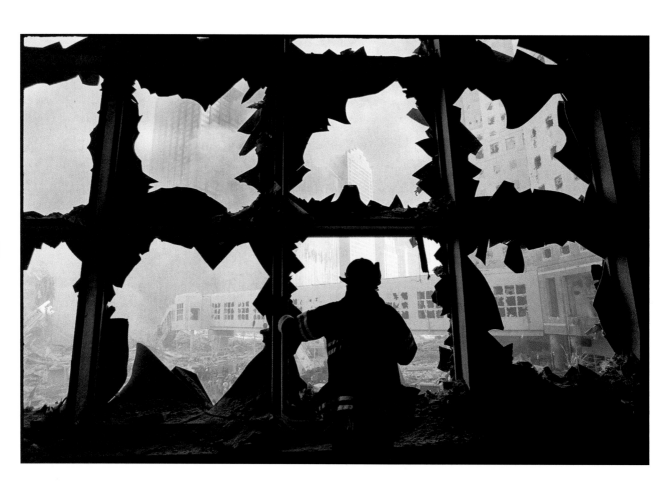

INSIDE TWO WORLD FINANCIAL CENTER, A HUSHED QUIET, THE INTERIOR COLORLESS, BOMBED OUT, A SHELL, REDUCED TO ITS MOST ROOT ELEMENTS: STAIRS, ROUND WALLS, WINDOWS, DUST. ONLY THE CEILING, THE BLUE COPULA, STILL INTACT. THE ESCALATORS ARE STILLED, COATED WITH BROKEN PLASTER AND GLASS. ON THE SECOND FLOOR, SHATTERED WRAPAROUND WINDOWS. BROKEN SHARDS OPENING A JAGGED VISTA ONTO THE THING ITSELF: GROUND ZERO.

THREE LARGE SPIKY REMNANTS OF THE TOWERS STICK OUT OF THE MOUND OF RUBBLE HELTER-SKELTER, TILTED ASKEW. SIX OR SEVEN STORIES TALL, THEY LOOK LIKE GIANT SEPULCHRAL HANDS REACHING OUT OF THE GROUND. THE BUILDINGS TO THE NORTH AND SOUTH ARE ON FIRE. CHUNKS ARE MISSING FROM OTHERS. THERE IS A TOTAL LOSS OF SCALE. NINE OR TEN FIRE AND RESCUE VEHICLES, THE FIRST ON THE SCENE, LIE AROUND THE FUNEREAL MOUND, BLOWN UPSIDE DOWN, STREWN ABOUT LIKE TONKA TOYS.

A DOZEN FIREMEN STAND TO THE RIGHT. A SINGLE YELLOW CRANE WORKS LISTLESSLY. ORANGE JUMPSUITS CRAWL AT THE EDGES OF THE DEBRIS LIKE ANTS. THERE IS NO MAJOR EFFORT IN PROGRESS. IT'S OVER. IT'S ALL GONE. A HANDFUL OF PHOTOGRAPHERS MOVE FROM WINDOW TO WINDOW, SCANNING THE WRECKAGE. NO ONE SPEAKS. THE SITE IS HOLY. MUFFLED FOOTFALLS CRUNCH OVER BROKEN GLASS IN THE DUST, A CHURCH ON THE EDGE OF THE ABYSS, A CHURCH OF APOCALYPTIC VISION, A CHURCH OF INCOMPREHENSIBLE DARKNESS, ON THE EDGE OF AN INSTANTANEOUS, MONUMENTAL GRAVE. NO BODIES, NO INJURED. THE DEVASTATION COMPLETE.

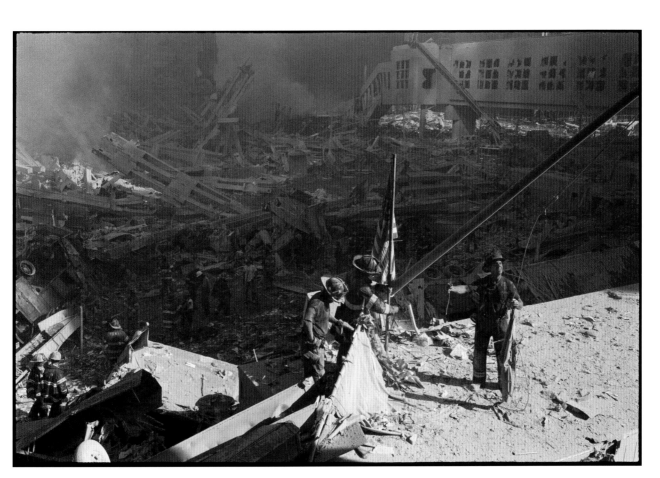

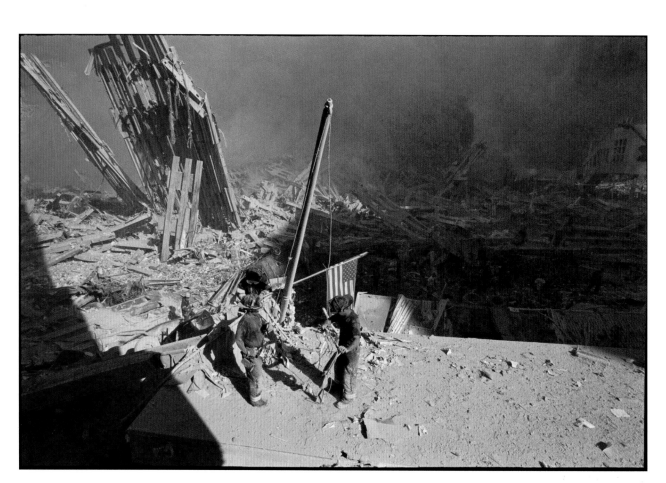

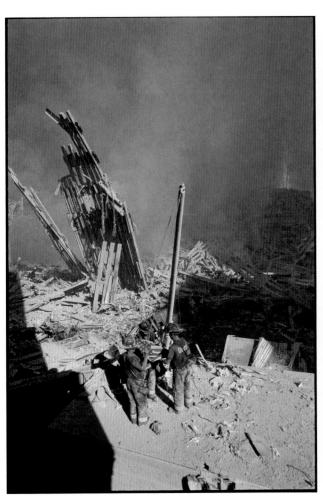

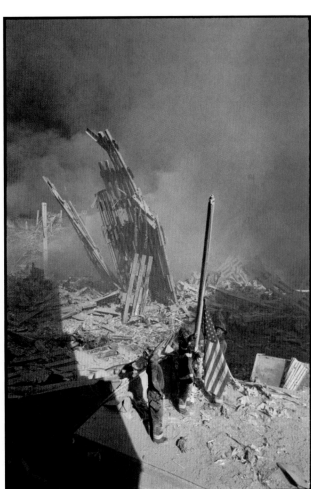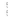

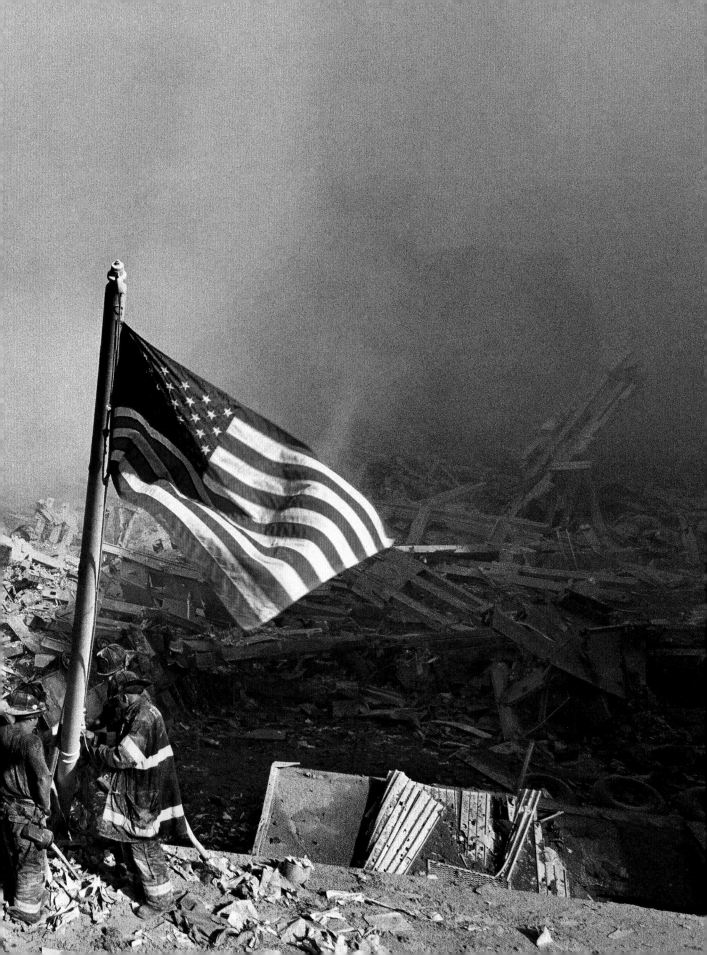

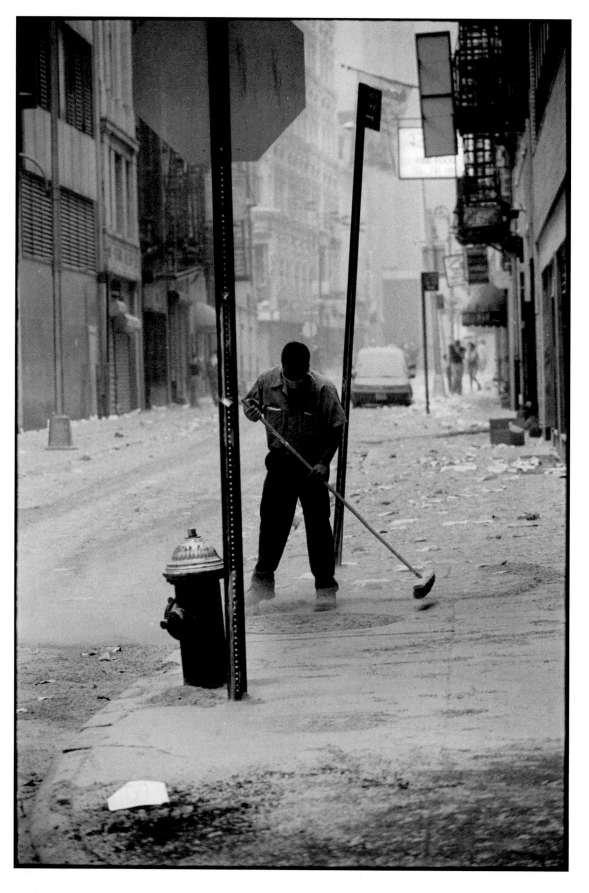

TWO HUNDRED AND TWENTY STORIES HAD COME DOWN. WHERE IS IT? THERE'S HARDLY A HILL. IT JUST VANISHED. SUCKED INTO THE VORTEX OF THE CITY'S SOFT UNDERBELLY. PIERCING MANHATTAN'S SHEET OF ASPHALT LIKE THE CRUST OF A CRÈME BRÛLEE.

ON THE WORLD FINANCIAL PLAZA TWO POLICEMEN INTERROGATE A KID WHO IS HOLDING A TWISTED BIT OF STEEL IN HIS HAND. "WHAT ARE YOU, SOUVENIR HUNTING?" ONE ASKS AGGRESSIVELY. "YOU KNOW THAT'S AGAINST THE LAW, THAT'S EVIDENCE. YOU'RE TAMPERING WITH EVIDENCE." THE CLAIM SEEMS PRE-POSTEROUS. THERE ARE BILLIONS OF FRAGMENTS OF EVIDENCE, BLOWN ALL OVER TOWN, EVIDENCE RAINING FROM THE SKY LIKE HAIL. WE ARE WALKING IN IT, COVERED IN IT, BREATHING IT IN.

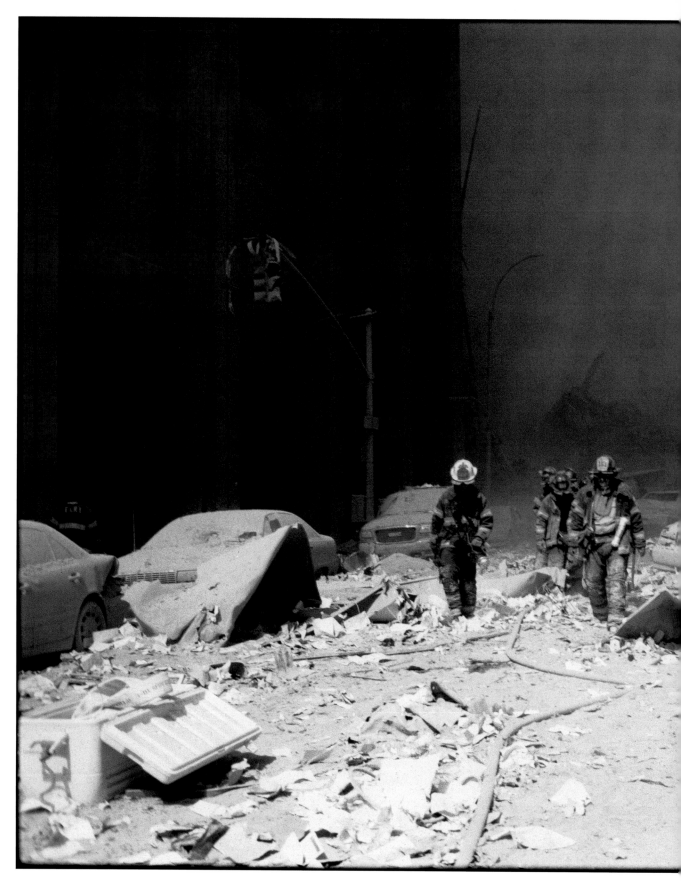

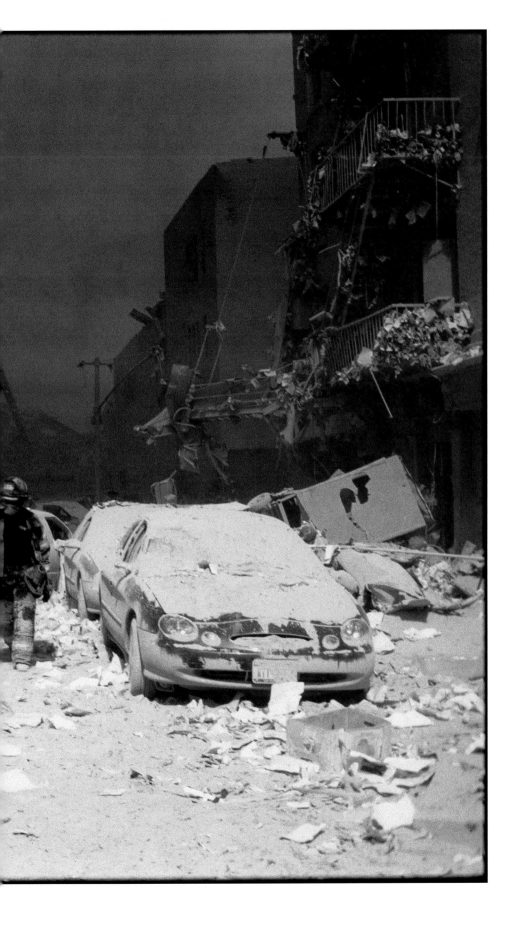

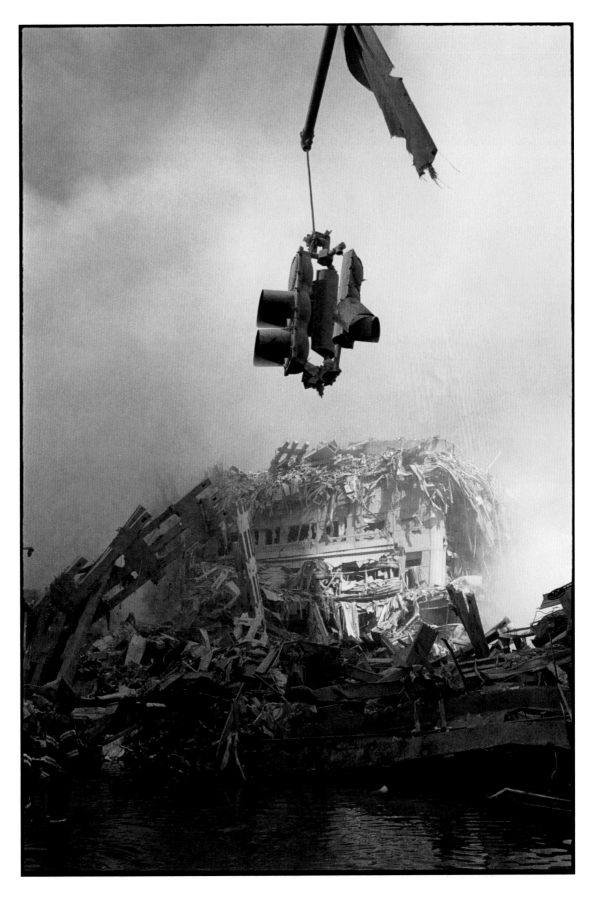

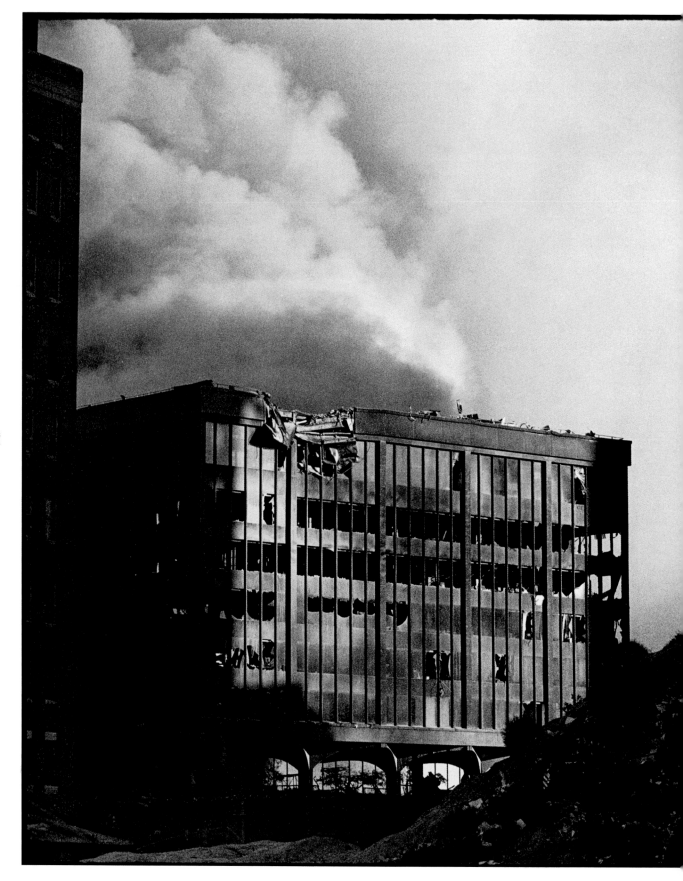

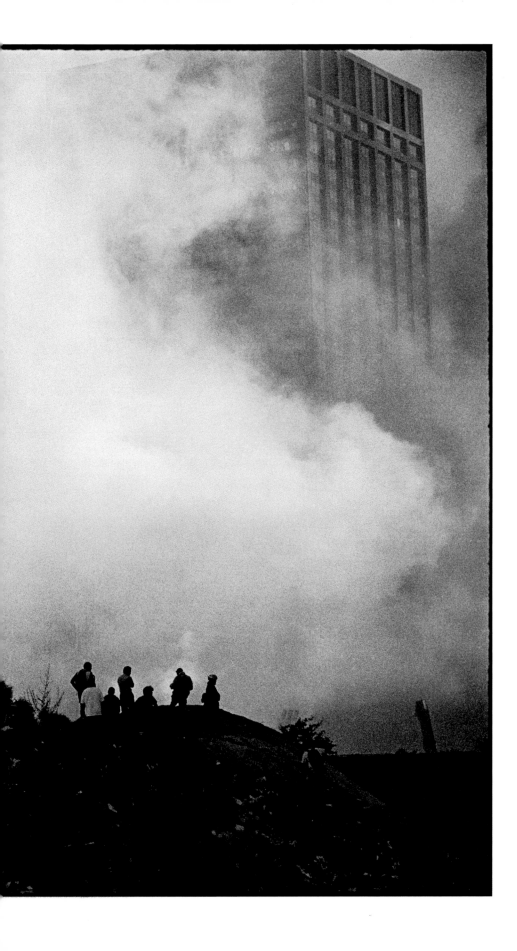

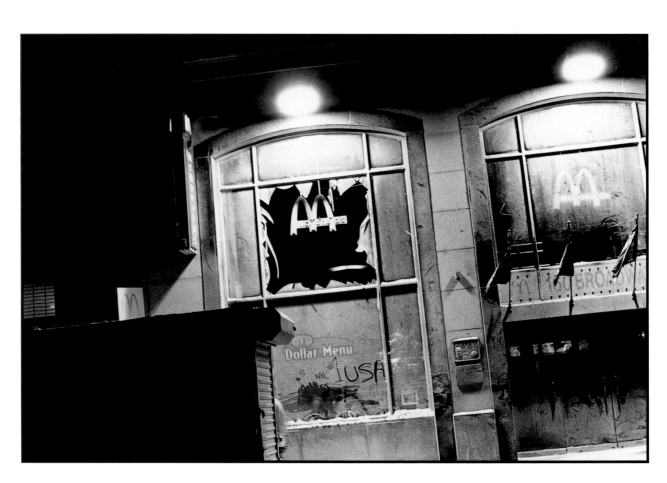

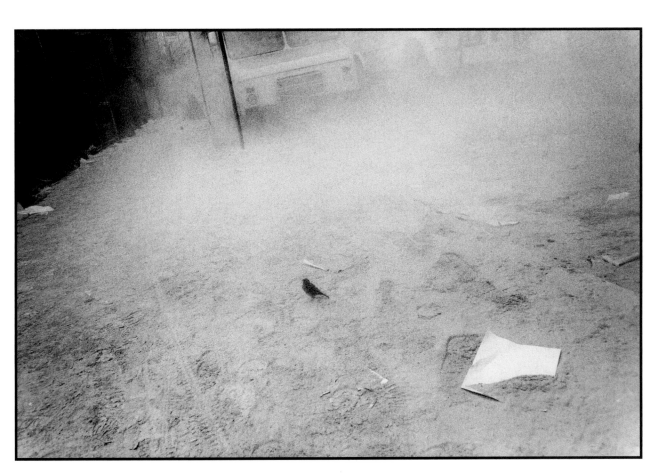

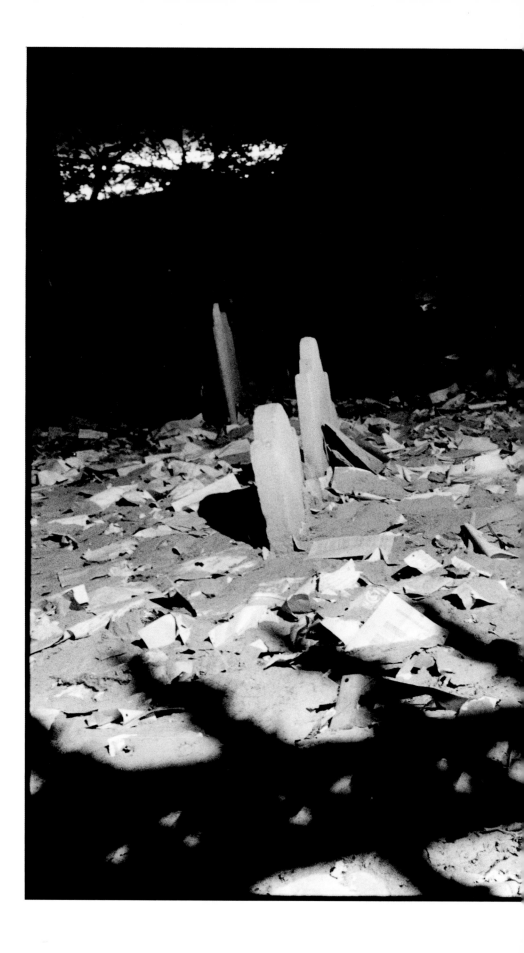

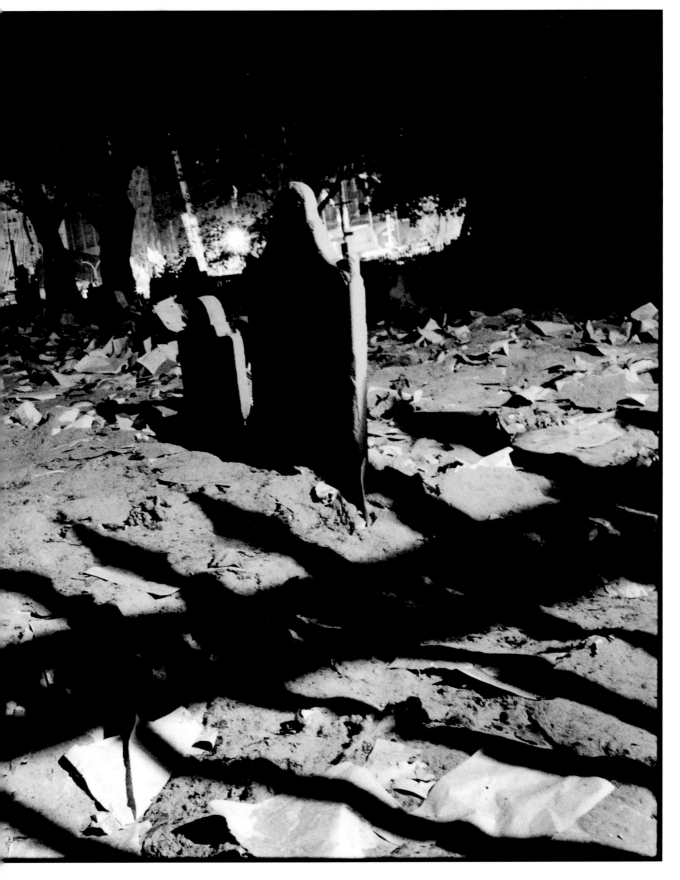

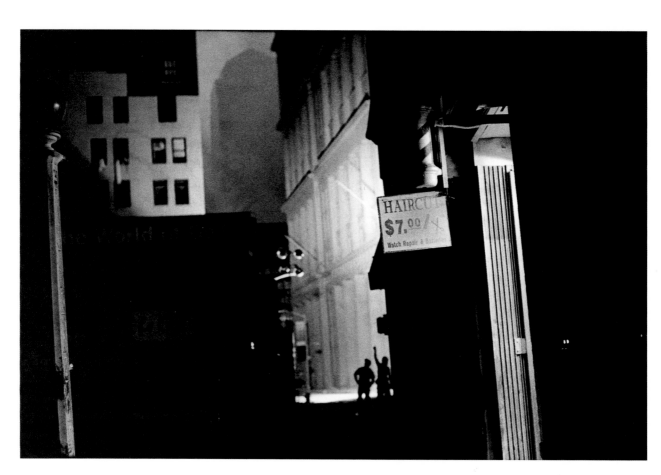

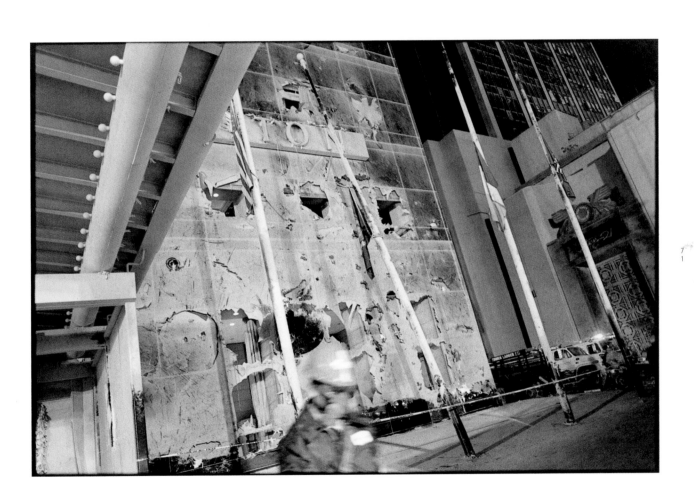

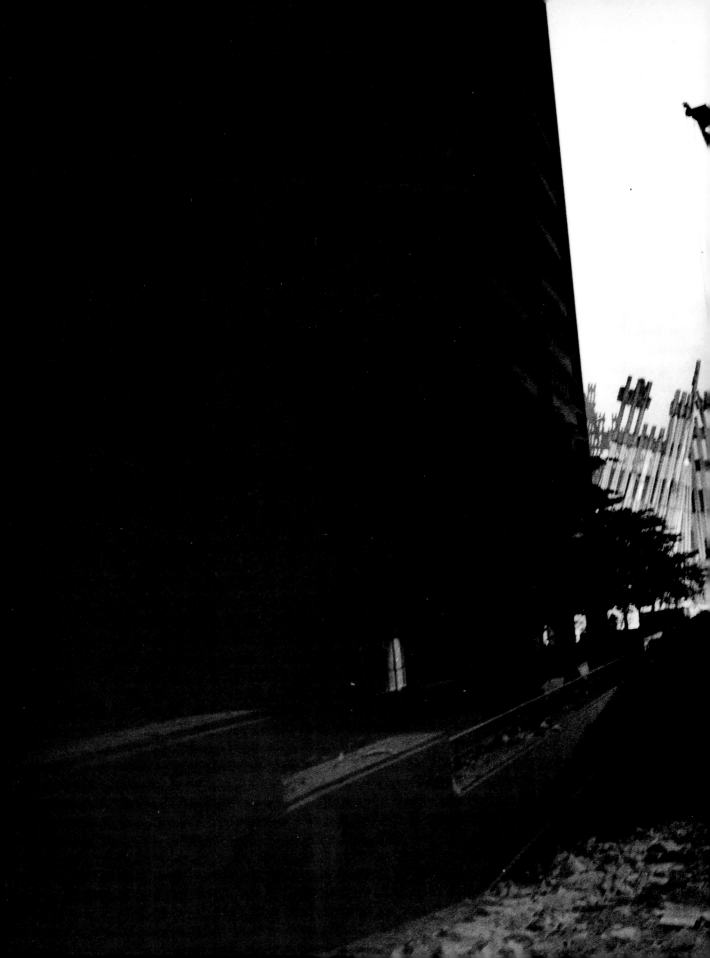

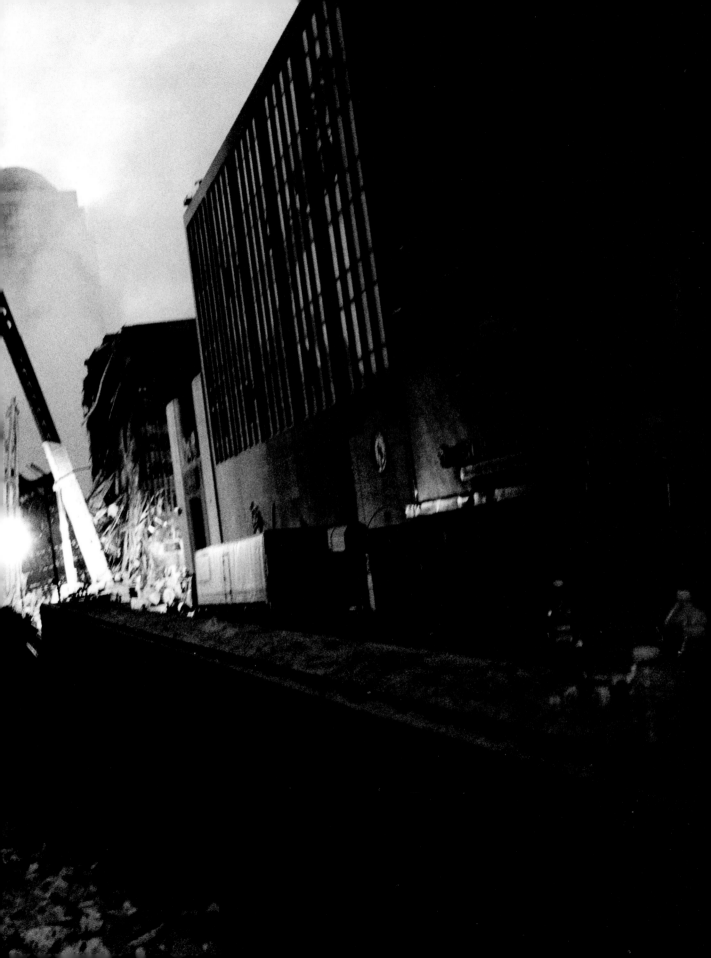

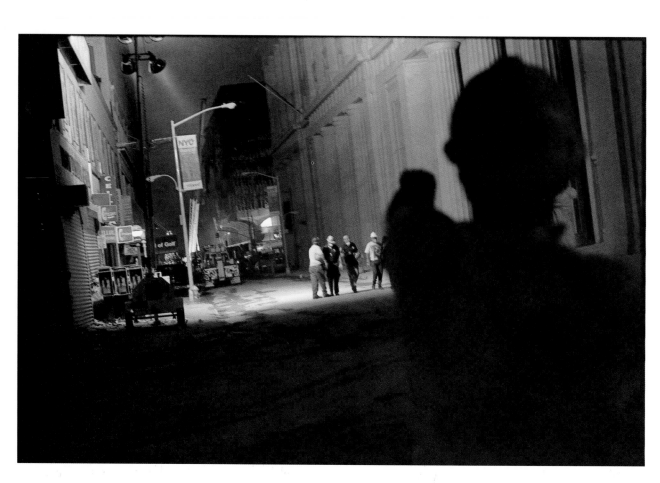

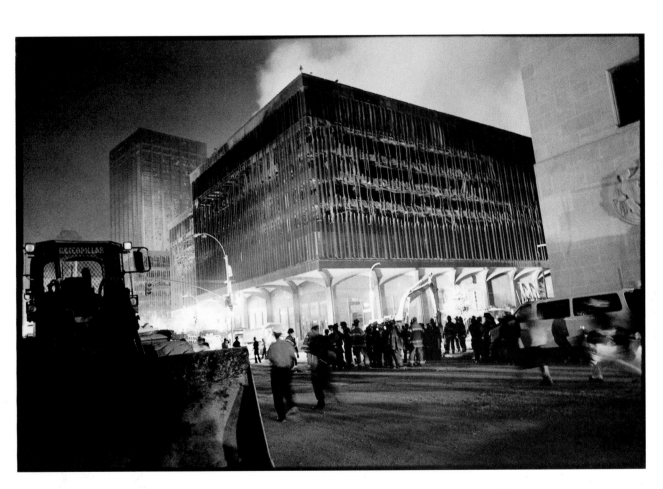

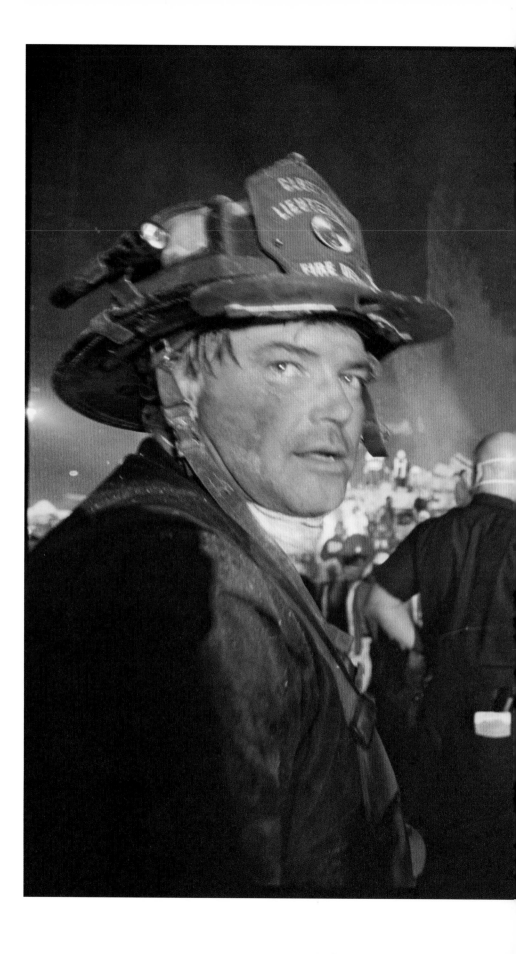

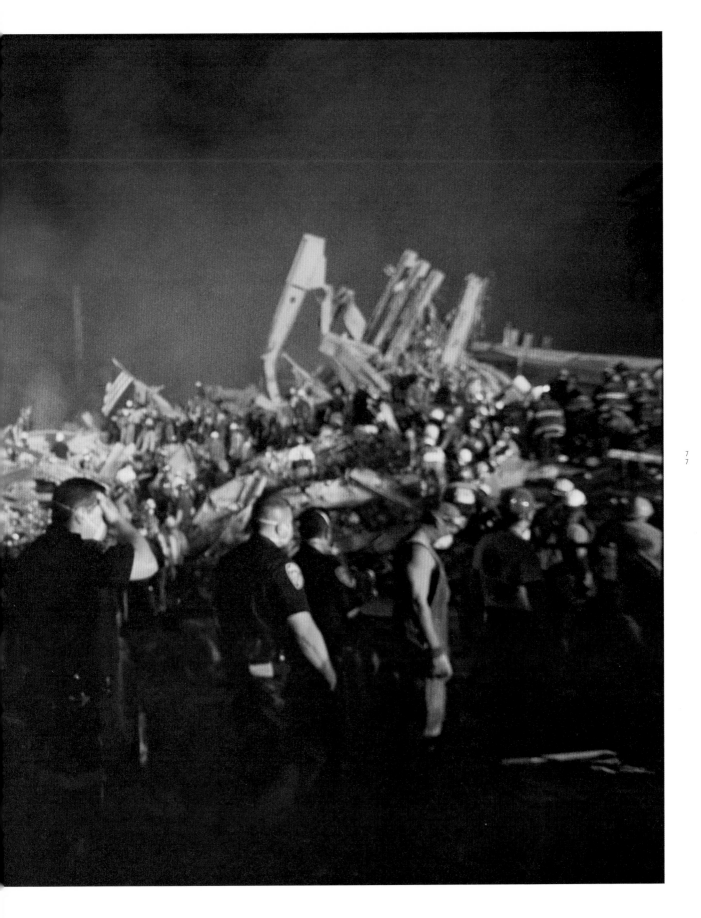

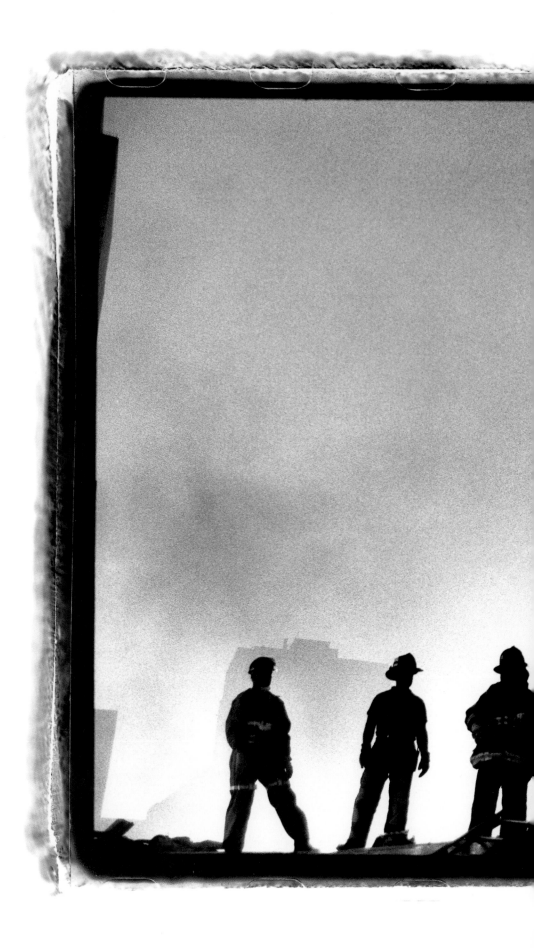

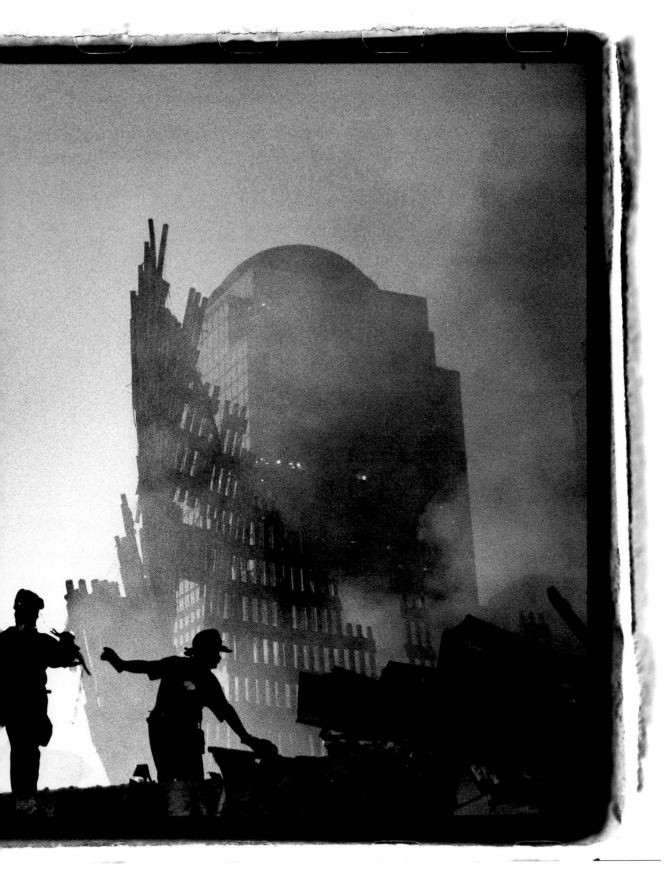

3 A.M. THE ATTACK BELONGED TO THE DAY. NOW NIGHT FALLS. STADIUM LIGHTS BATHE THE DOWNTOWN SKY IN A SPECTRAL MOVIE GLOW. BLACK HELICOPTERS HANG IN THE SKY BETWEEN THE BUILDINGS LIKE GREAT PREHISTORIC BIRDS. SMOKE FLITS UPWARD FROM THE BROKEN STEEL, STEALING OVER THE STREETS, TIME IN SUSPENSION, DETACHED FROM THE HANDS OF CLOCKS, GHOSTS EVERYWHERE.

HEAVY CRANES RUMBLE BACK AND FORTH ON CHURCH STREET. FOR AN INSTANT THEIR MECHANICAL ARMS PART AND THE PILE OF WRECKAGE IS GLIMPSED BLAZING UNDER THE LIGHTS. THE PILE IS MOVING, FLUCTUATING, ROLLING LIKE LIQUID GELATIN. IT TAKES A MOMENT TO REALIZE IT IS CARPETED WITH HUNDREDS OF PEOPLE. AT THE HIGHEST POINT A MAN IN AN ORANGE VEST FLAPS HIS ARMS UP AND DOWN AND THE HUMAN SEA REPLICATES HIS GESTURE, DIGGING. THEN THE MACHINES MOVE ON, CLOSING UP THE LINE OF SIGHT.

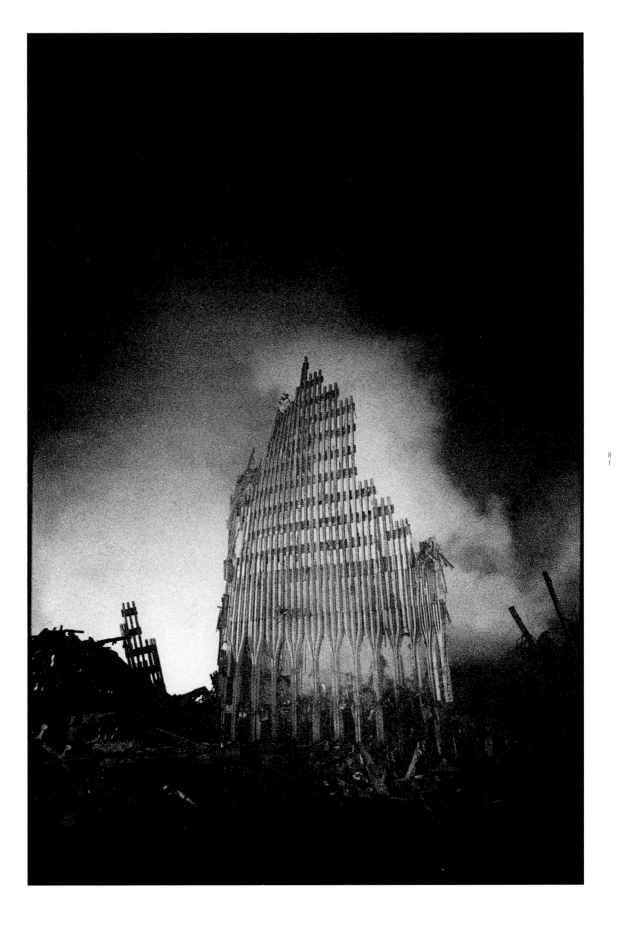

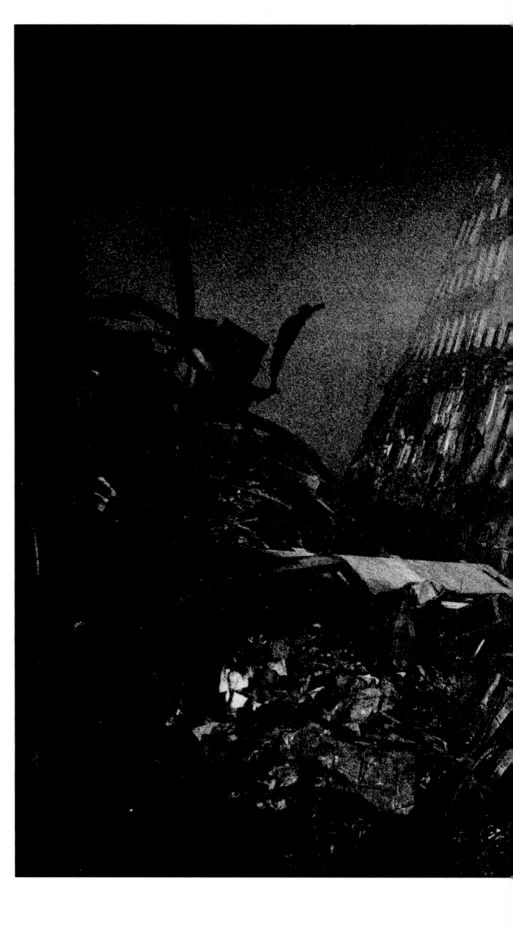

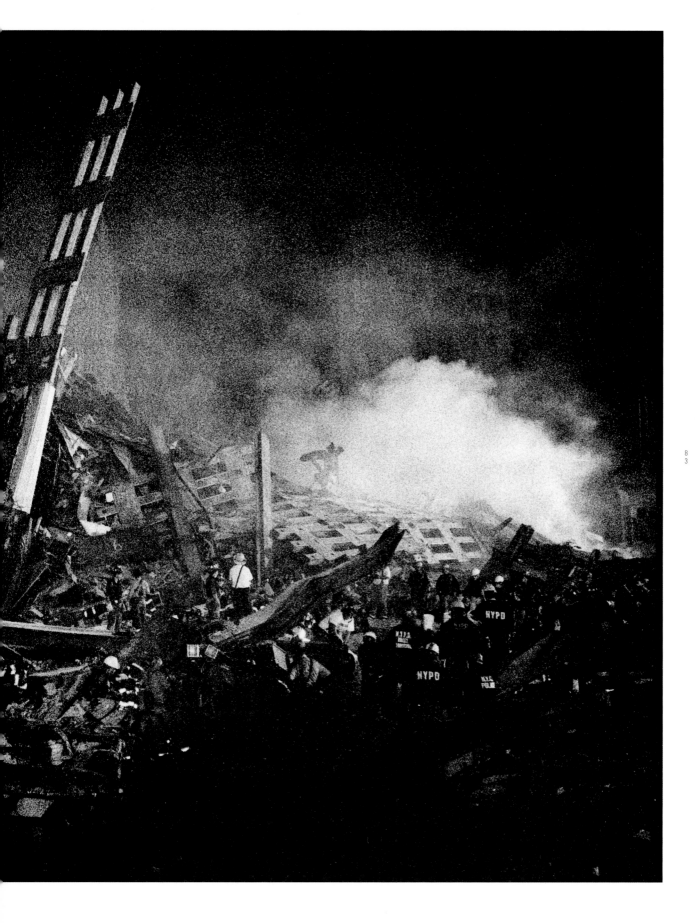

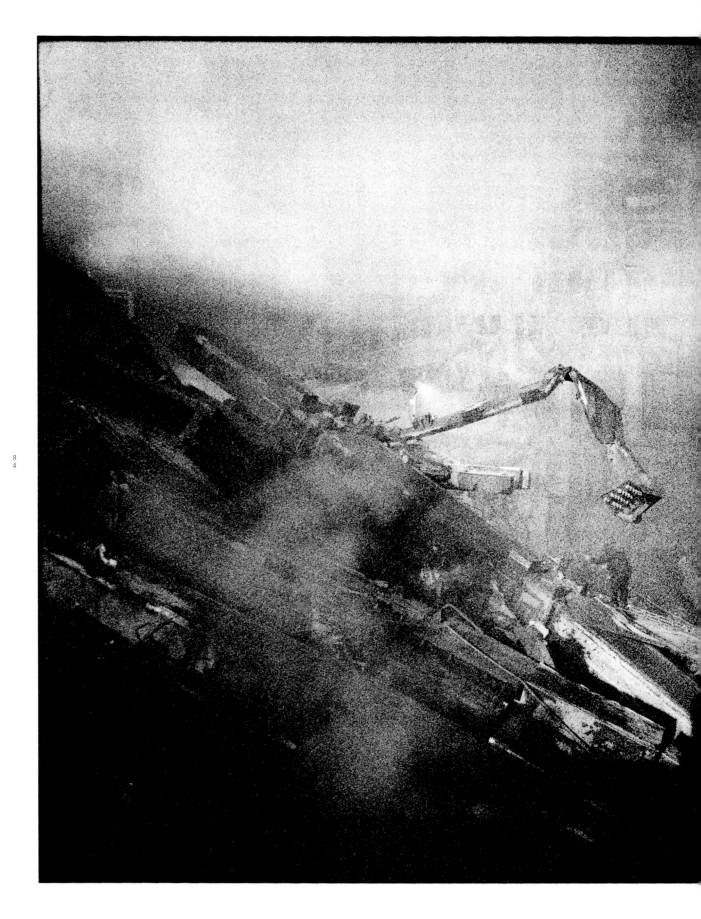

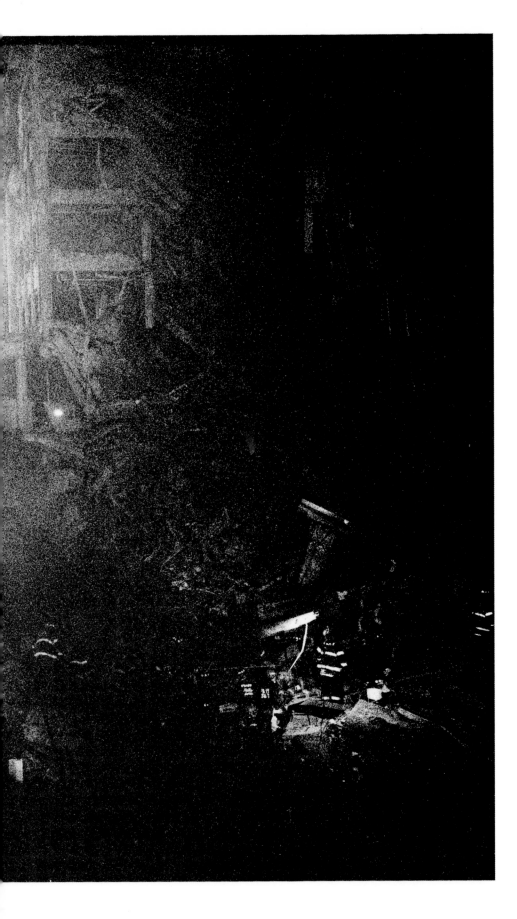

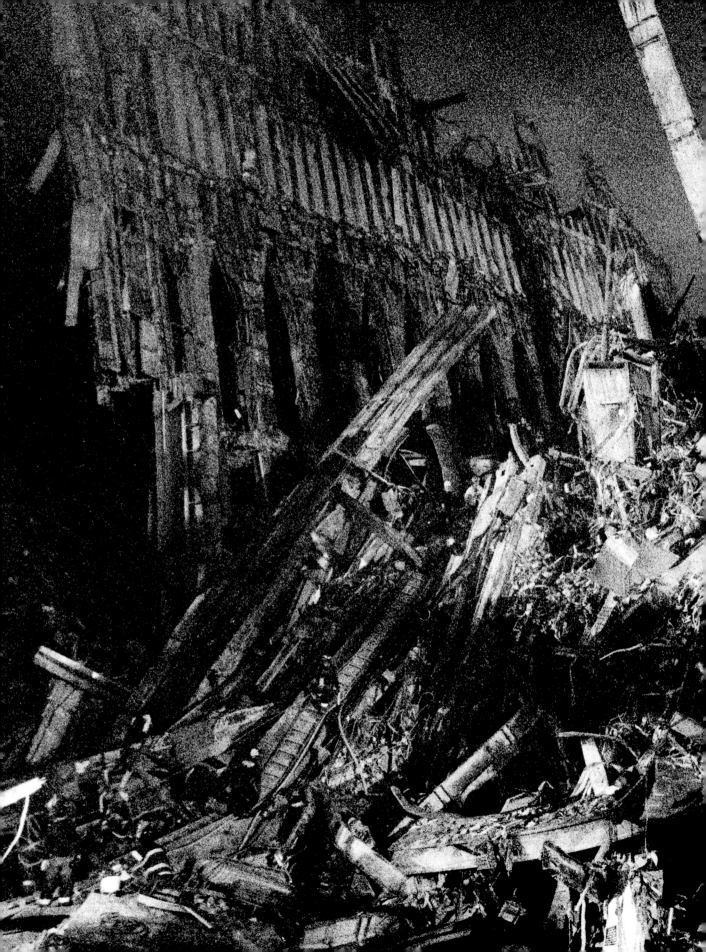

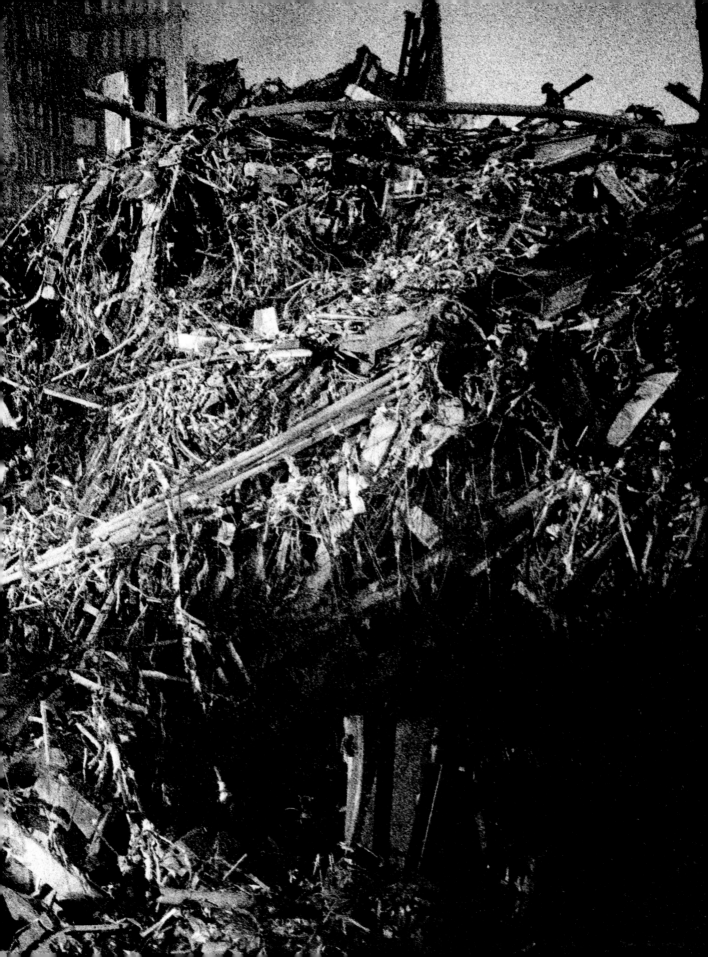

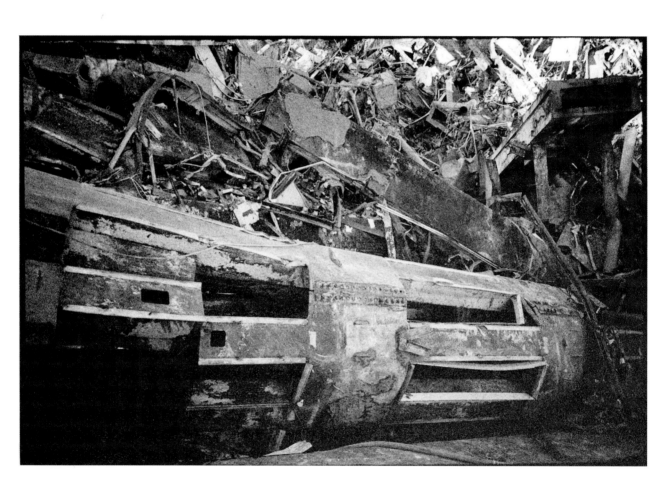

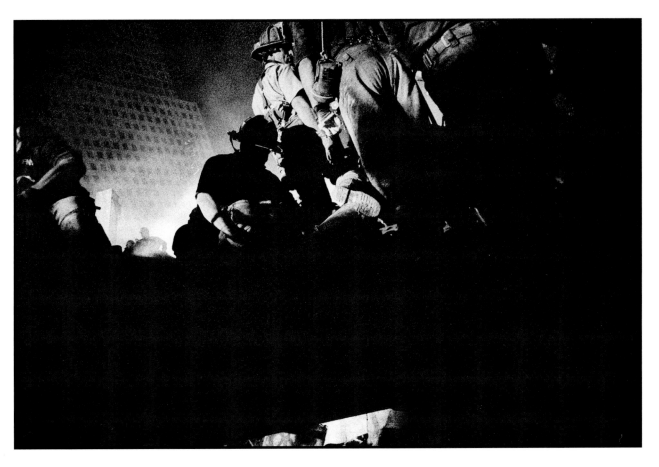

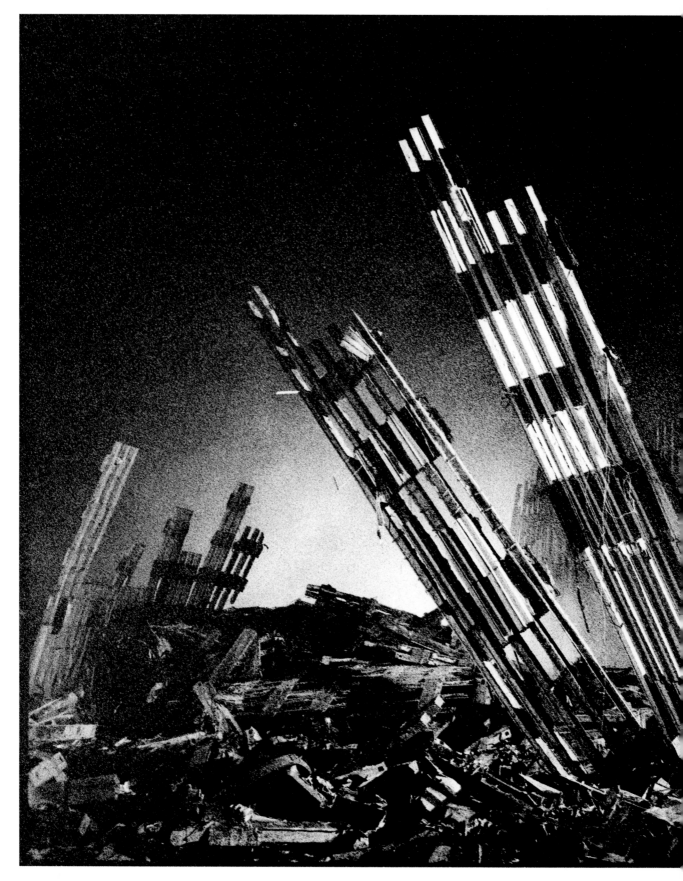

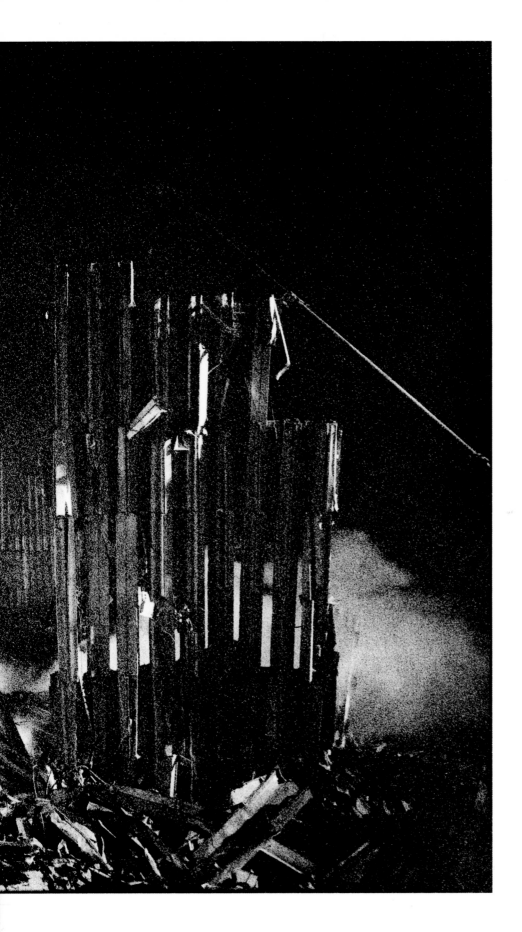

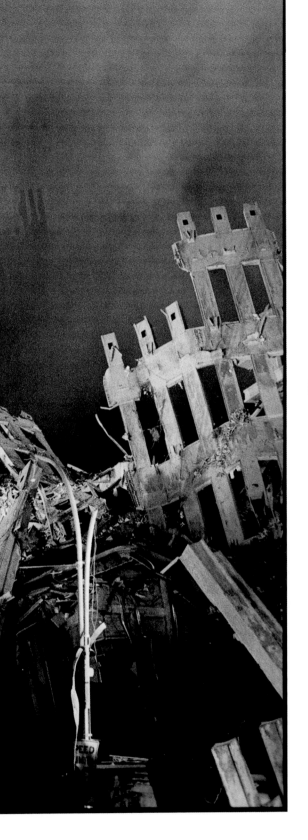

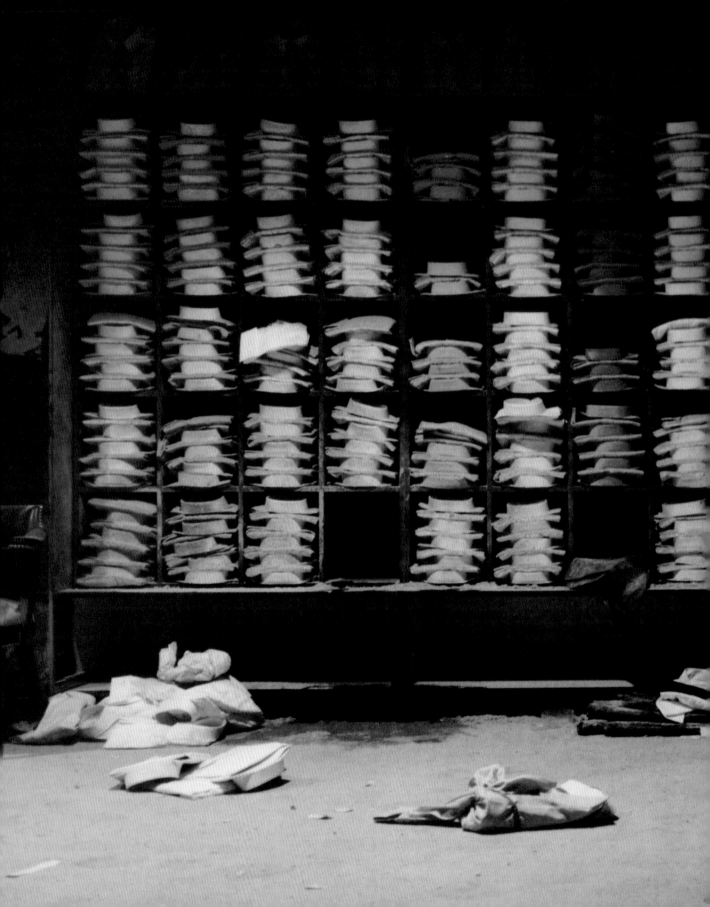

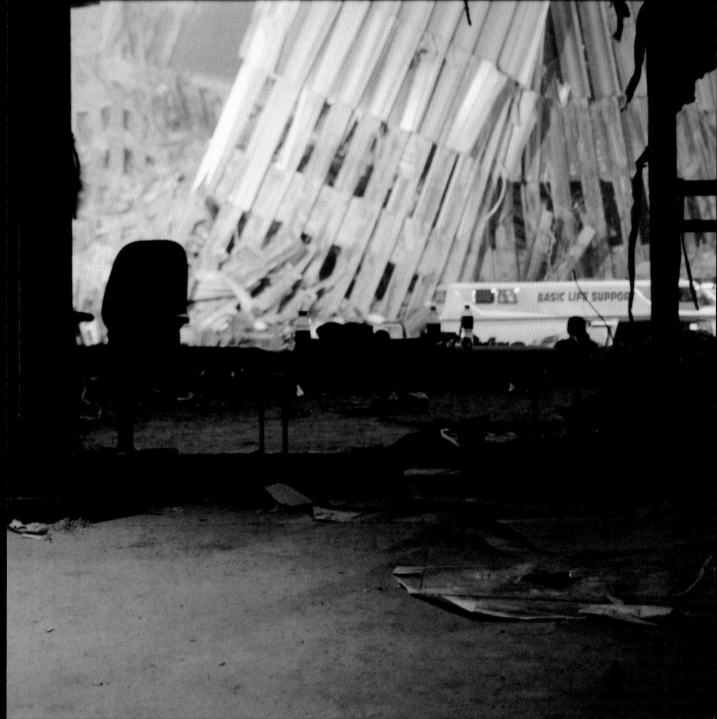

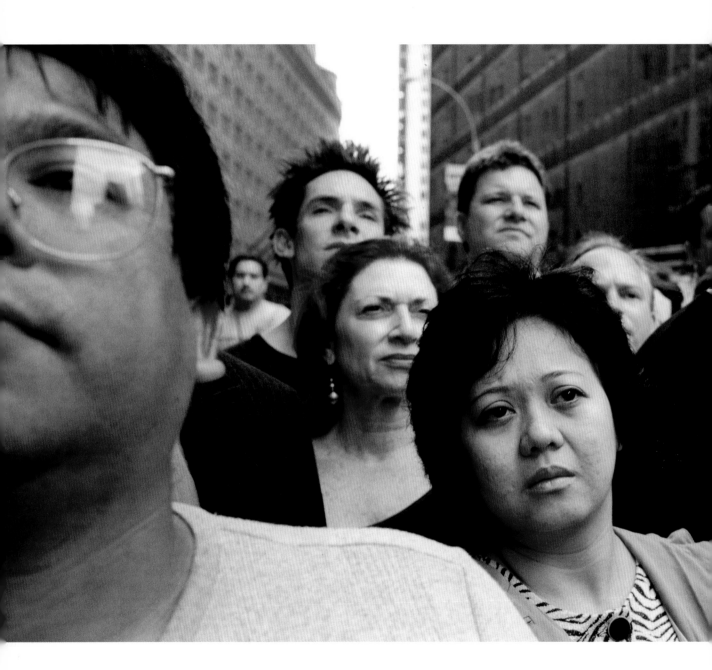

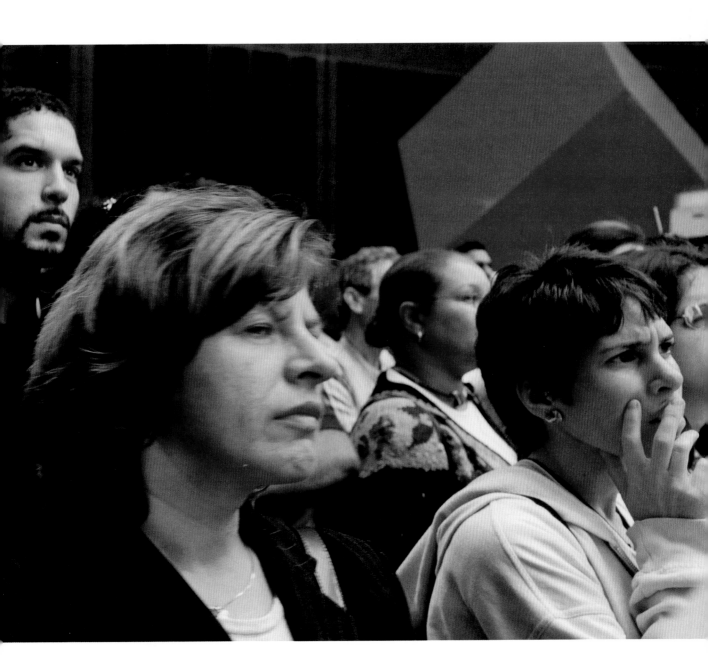

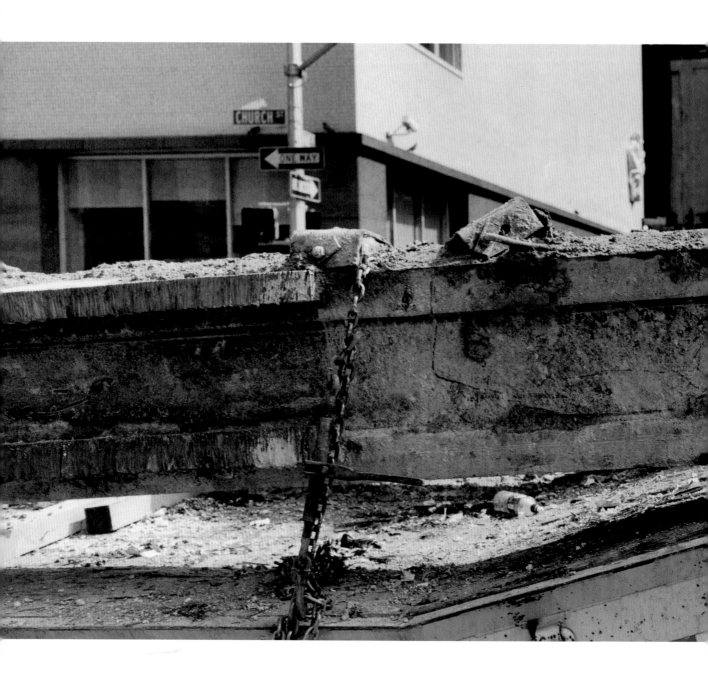

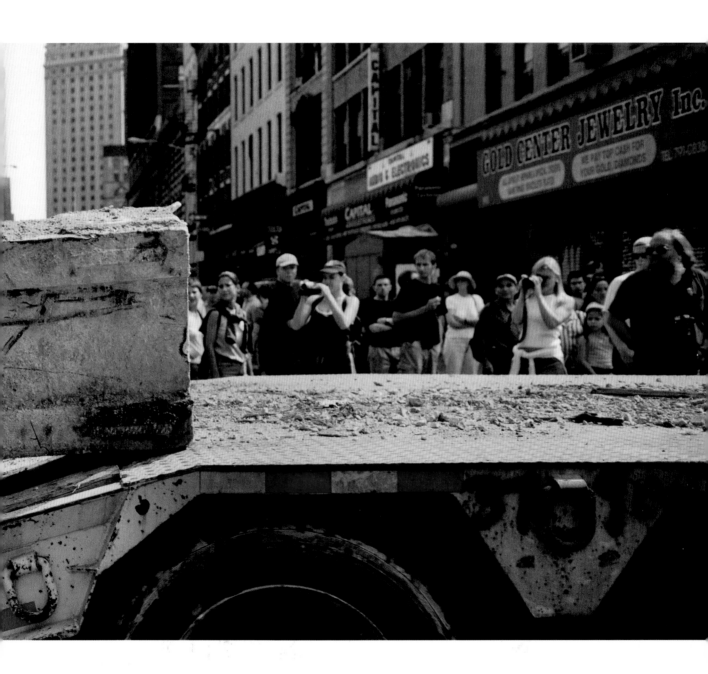

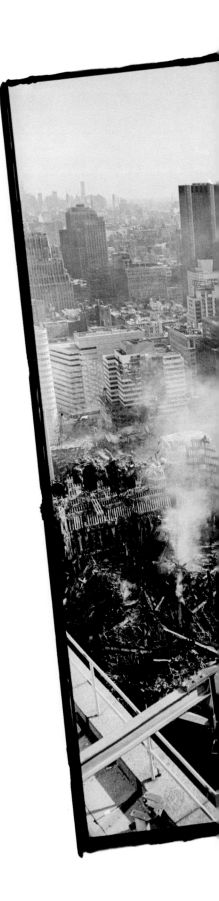

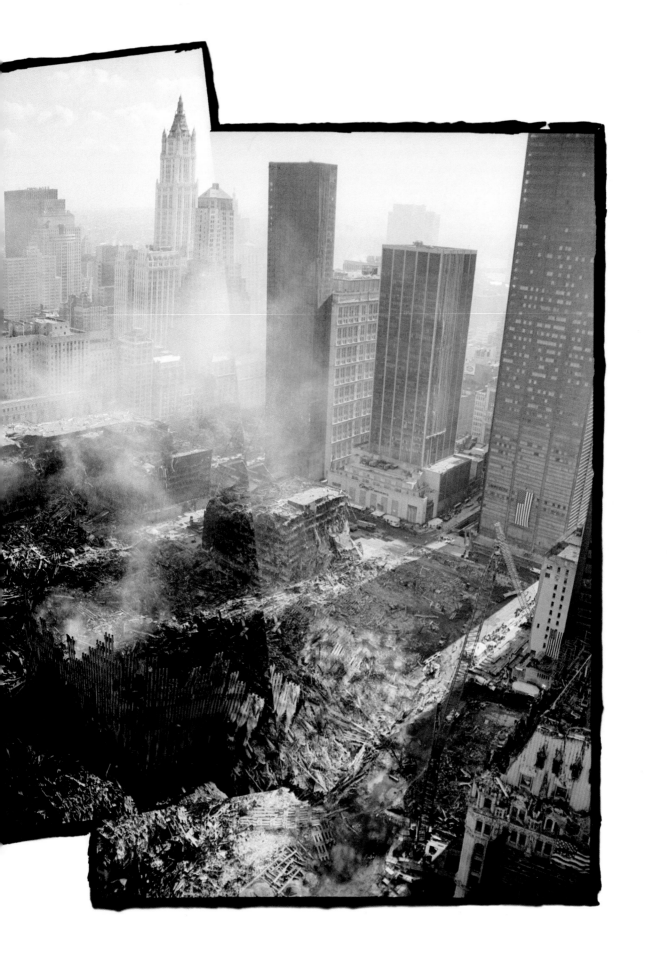

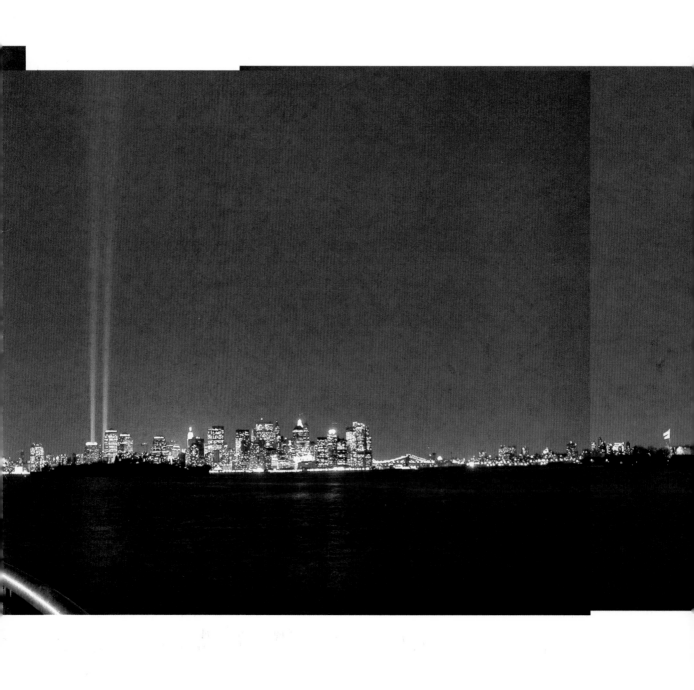

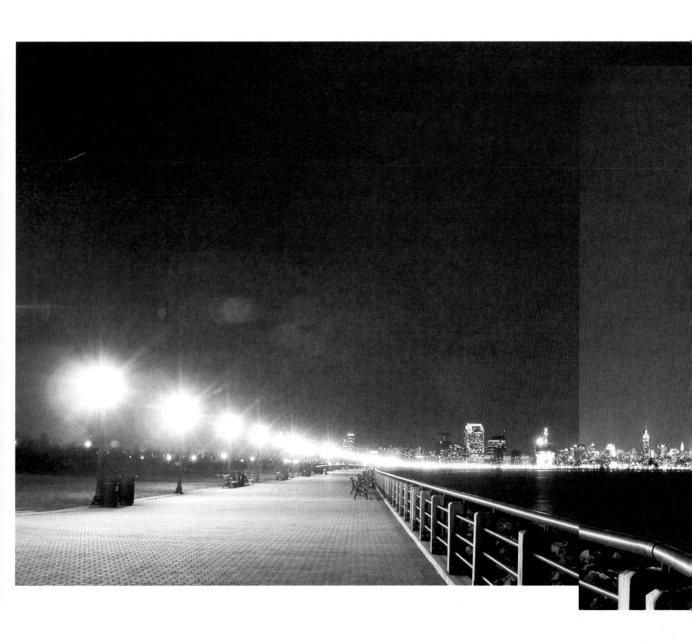

THE DEAD OF SEPTEMBER 11

SOME HAVE GOD'S WORDS; OTHERS HAVE SONGS OF COMFORT FOR THE BEREAVED. IF I CAN PLUCK COURAGE HERE, I WOULD LIKE TO SPEAK DIRECTLY TO THE DEAD—THE SEPTEMBER DEAD. THOSE CHILDREN OF ANCESTORS BORN IN EVERY CONTINENT ON THE PLANET: ASIA, EUROPE, AFRICA, THE AMERI-CAS...; BORN OF ANCESTORS WHO WORE KILTS, OBIS, SARIS, GÈLÈS, WIDE STRAW HATS, YARMULKES, GOATSKIN, WOODEN SHOES, FEATHERS AND CLOTHS TO COVER THEIR HAIR. BUT I WOULD NOT SAY A WORD UNTIL I COULD SET ASIDE ALL I KNOW OR BELIEVE ABOUT NATIONS, WARS, LEADERS, THE GOVERNED AND THE UNGOVERNABLE; ALL I SUSPECT ABOUT ARMOR AND ENTRAILS. FIRST I WOULD FRESHEN MY TONGUE, ABANDON SENTENCES CRAFTED TO KNOW EVIL— WANTON OR STUDIED; EXPLOSIVE OR QUIETLY SINISTER; WHETHER BORN OF A SATED APPETITE OR HUNGER; OF VEN-GEANCE OR THE SIMPLE COMPULSION TO STAND UP BEFORE FALLING DOWN. I WOULD PURGE MY LANGUAGE OF HYPER-BOLE; OF ITS EAGERNESS TO ANALYZE THE LEVELS OF WICKEDNESS; RANKING THEM; CALCULATING THEIR HIGHER OR LOWER STATUS AMONG OTHERS OF ITS KIND. SPEAKING TO THE BROKEN AND THE DEAD IS TOO DIFFICULT FOR A MOUTH FULL OF BLOOD. TOO HOLY AN ACT FOR IMPURE THOUGHTS. BECAUSE THE DEAD ARE FREE, ABSOLUTE; THEY CANNOT BE SEDUCED BY BLITZ.

TO SPEAK TO YOU, THE DEAD OF SEPTEM-BER, I MUST NOT CLAIM FALSE INTIMACY OR SUMMON AN OVERHEATED HEART GLAZED JUST IN TIME FOR A CAMERA. I MUST BE STEADY AND I MUST BE CLEAR, KNOWING ALL THE TIME THAT I HAVE NOTHING TO SAY—NO WORDS STRONGER THAN THE STEEL THAT PRESSED YOU INTO ITSELF; NO SCRIPTURE OLDER OR MORE ELEGANT THAN THE ANCIENT ATOMS YOU HAVE BECOME.

AND I HAVE NOTHING TO GIVE EITHER— EXCEPT THIS GESTURE, THIS THREAD THROWN BETWEEN YOUR HUMANITY AND MINE: I *WANT TO HOLD YOU IN MY ARMS* AND AS YOUR SOUL GOT SHOT OF ITS BOX OF FLESH TO UNDERSTAND, AS YOU HAVE DONE, THE WIT OF ETERNITY: ITS GIFT OF UNHINGED RELEASE TEAR-ING THROUGH THE DARKNESS OF ITS KNELL. **TONI MORRISON**

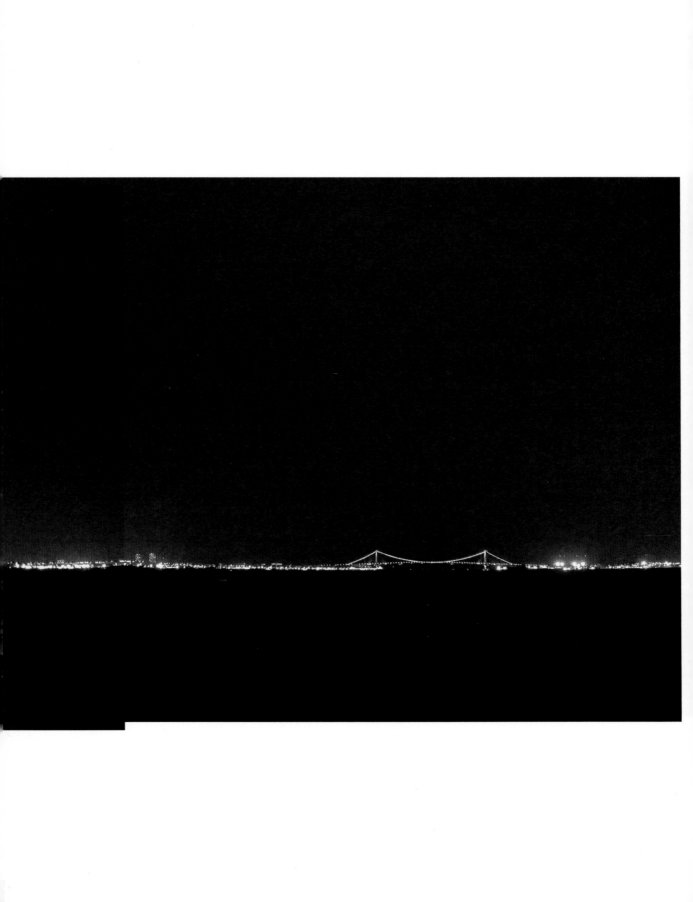

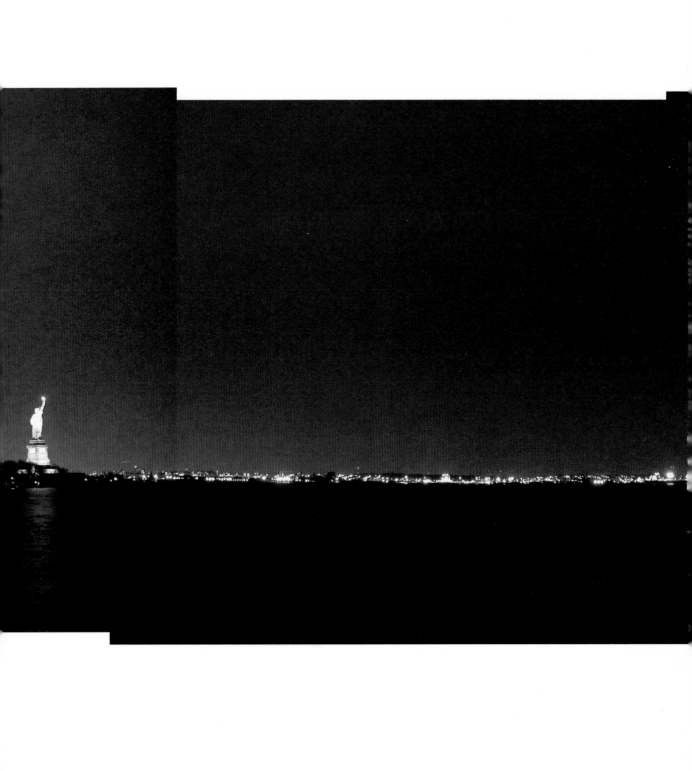

1974-2001

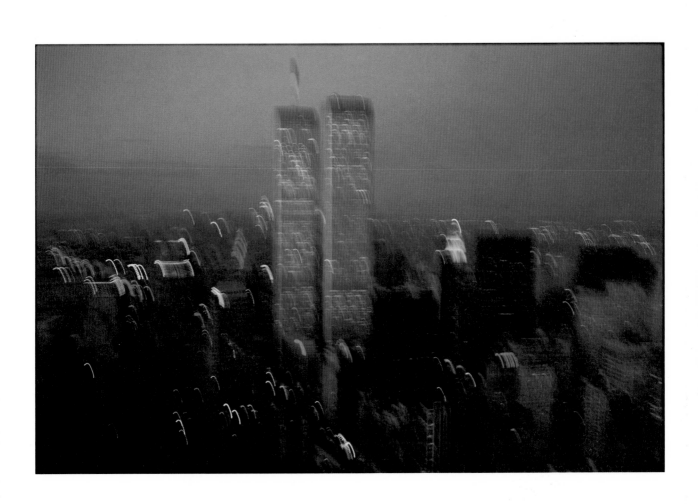

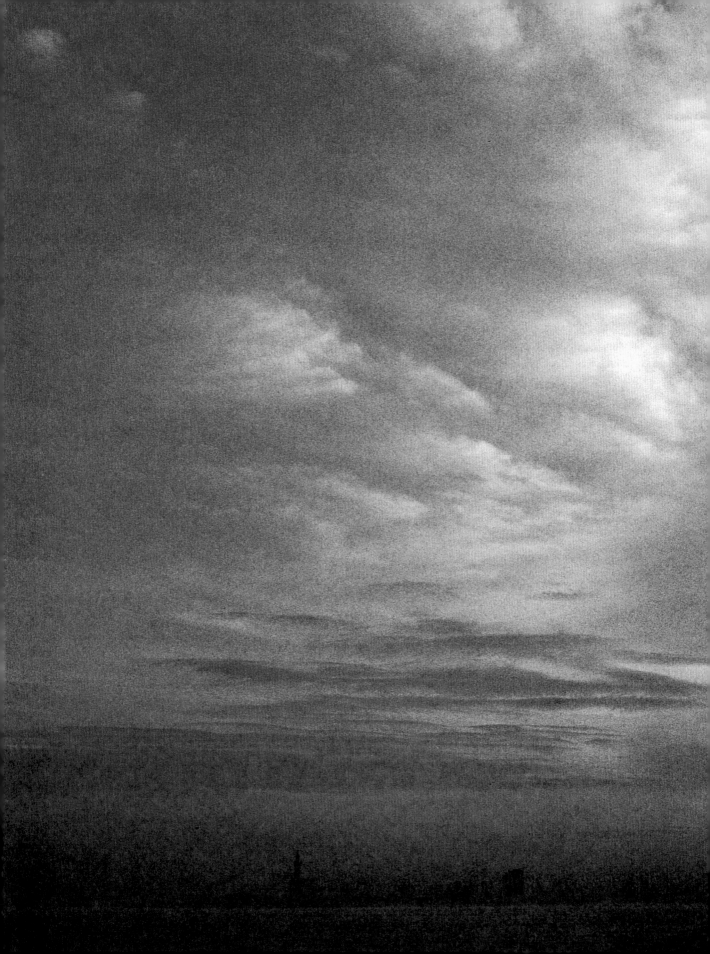

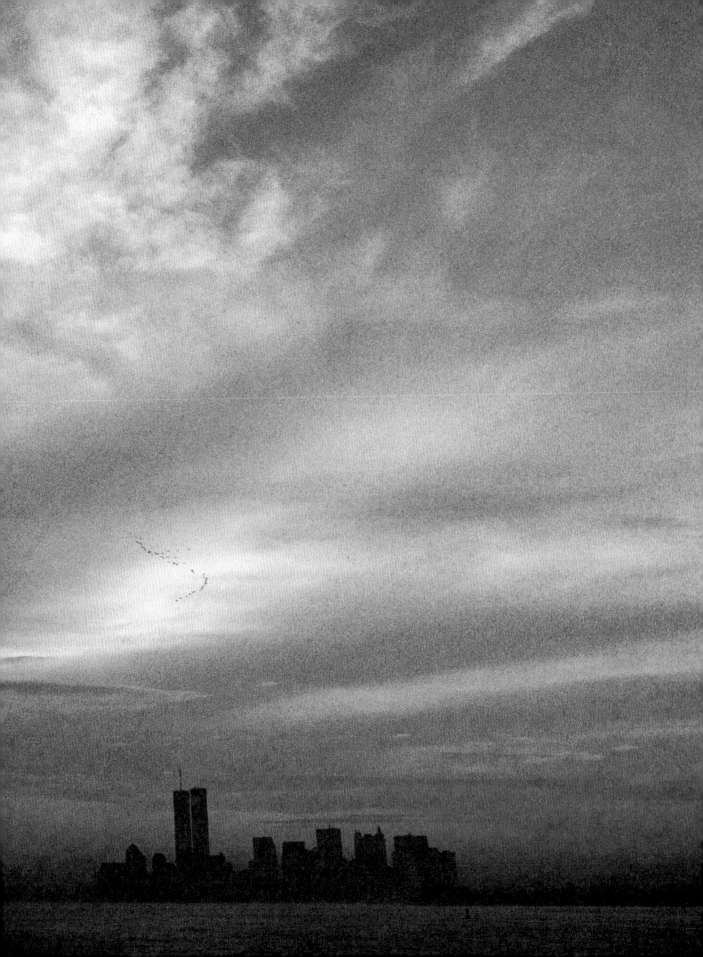

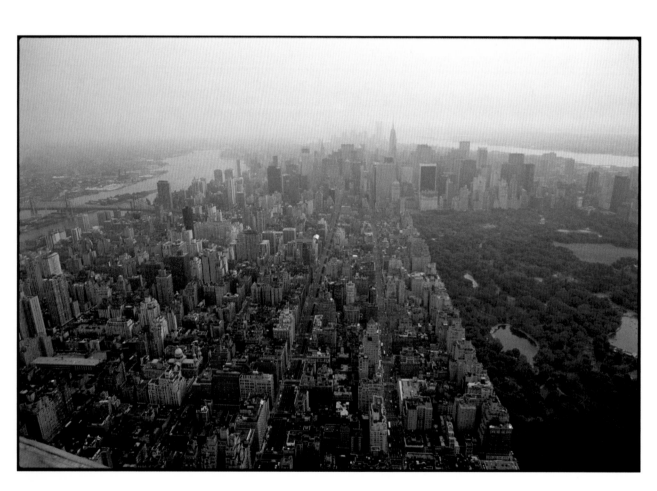

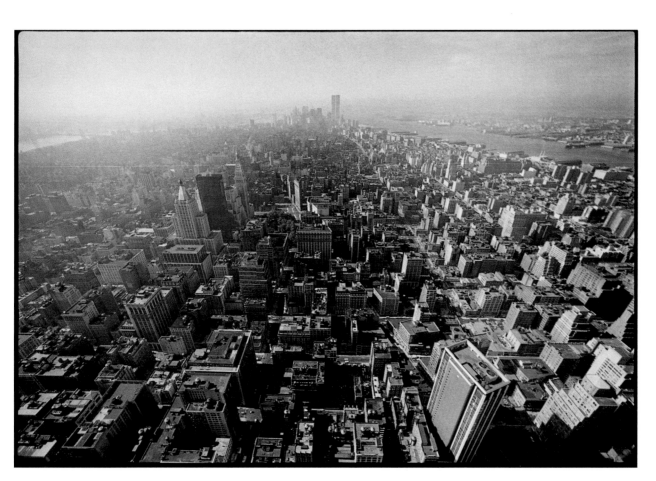

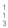

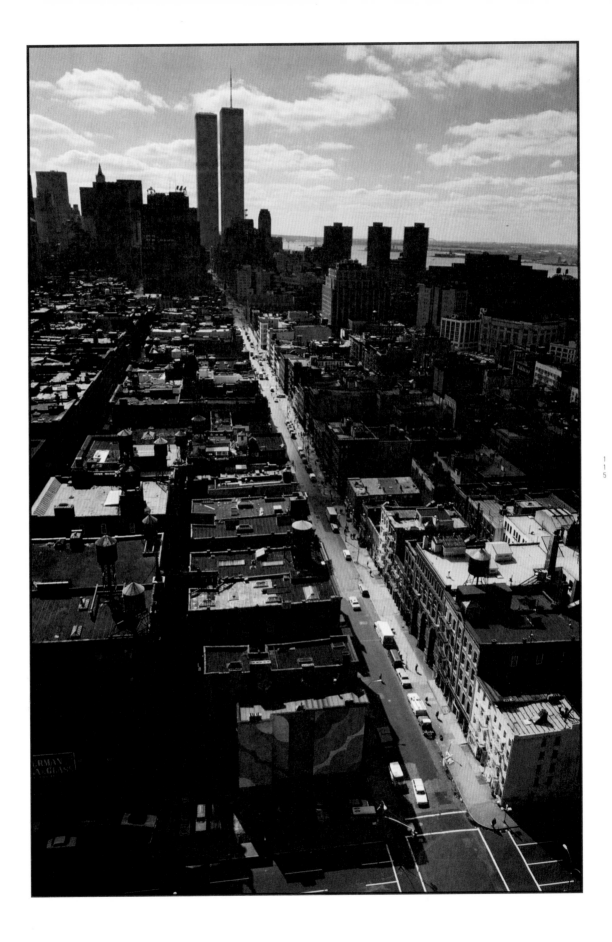

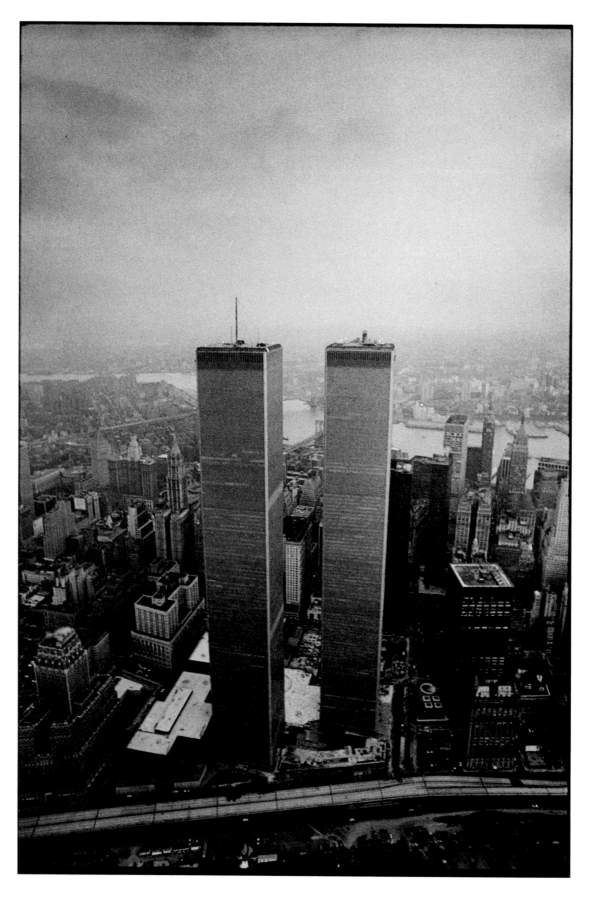

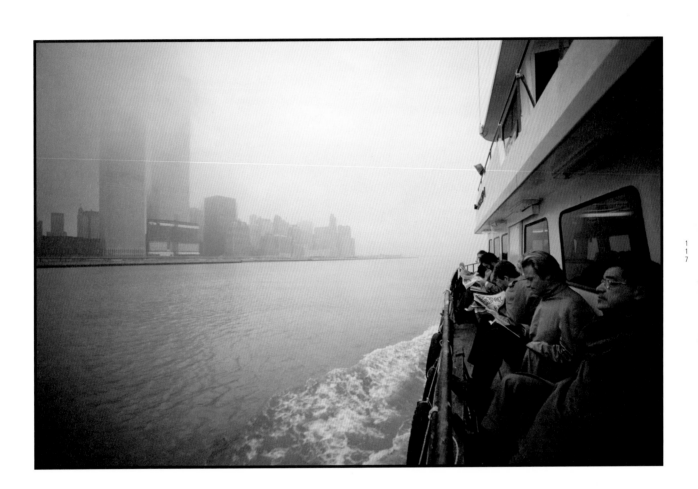

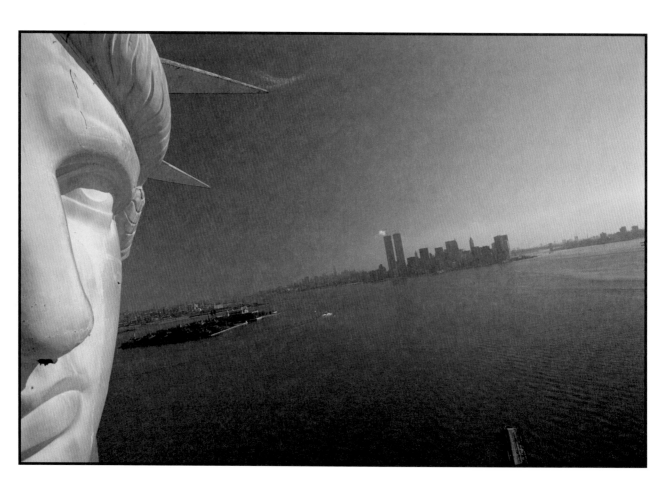

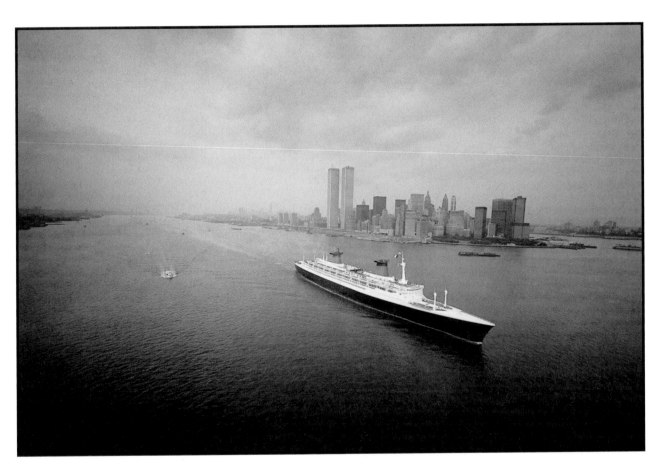

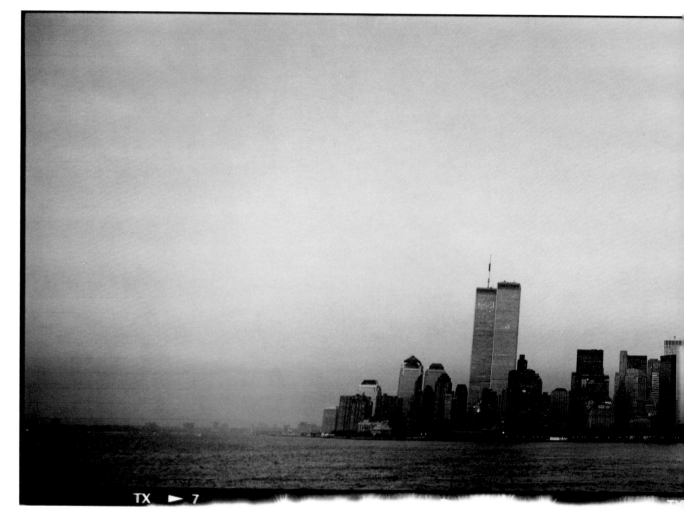

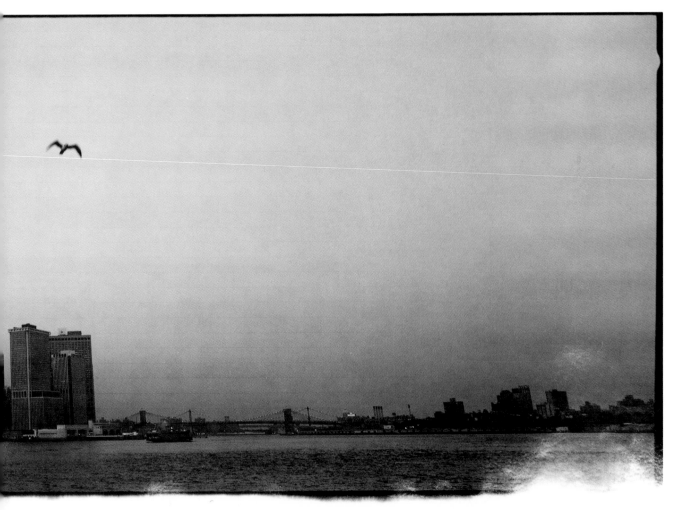

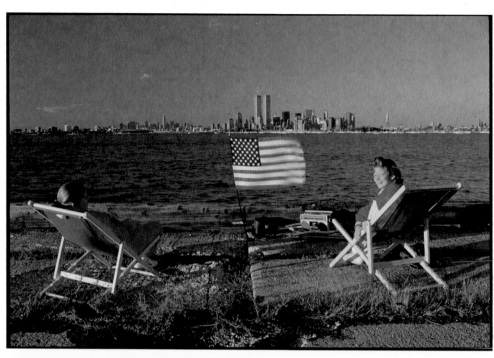

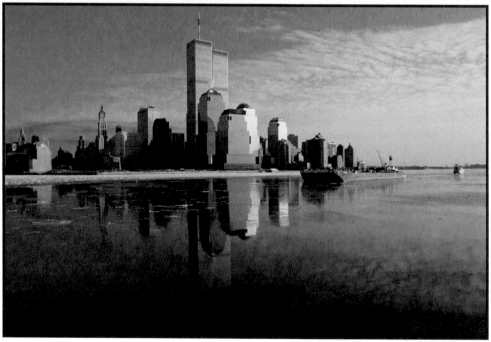

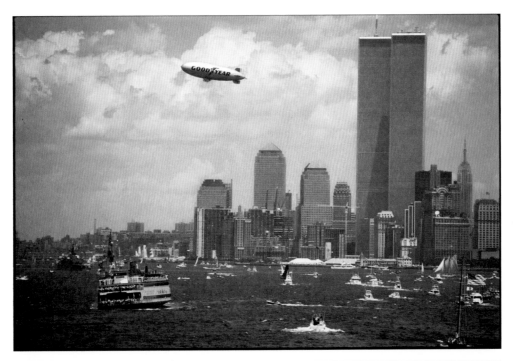

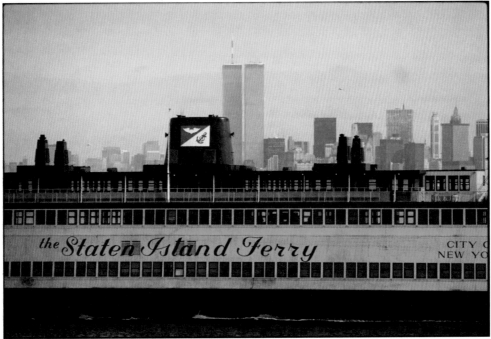

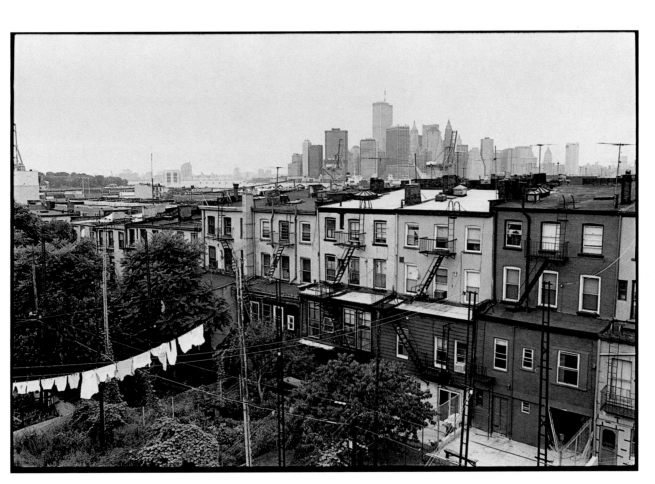

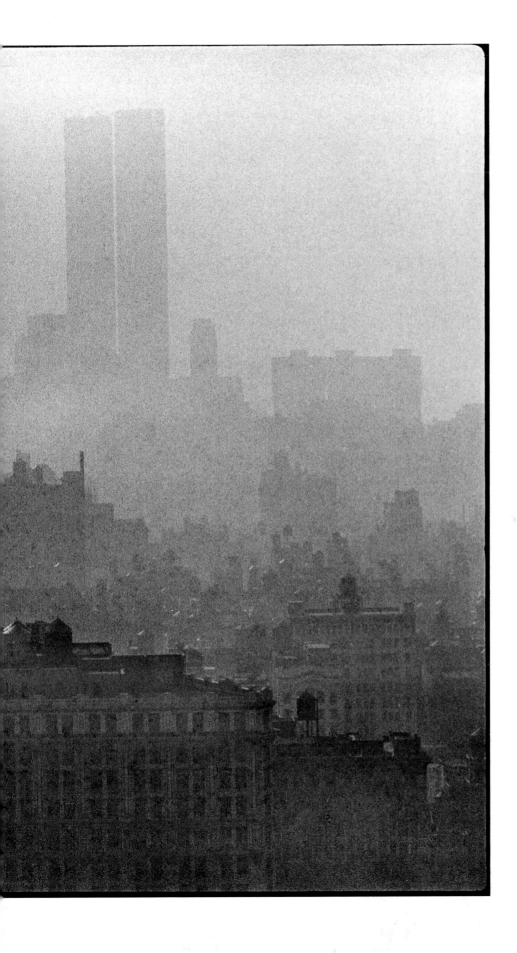

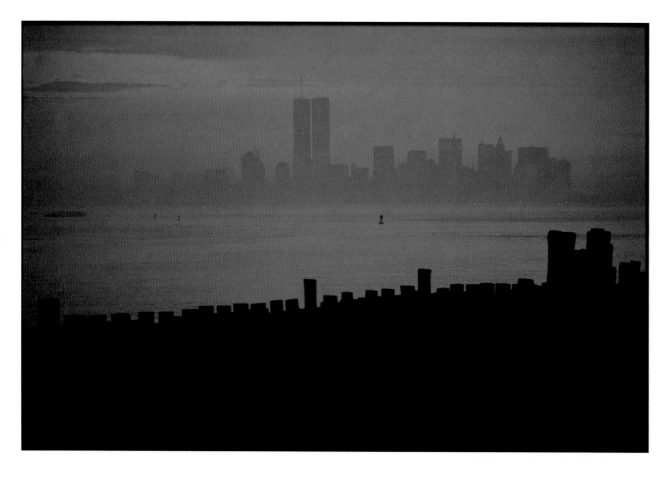

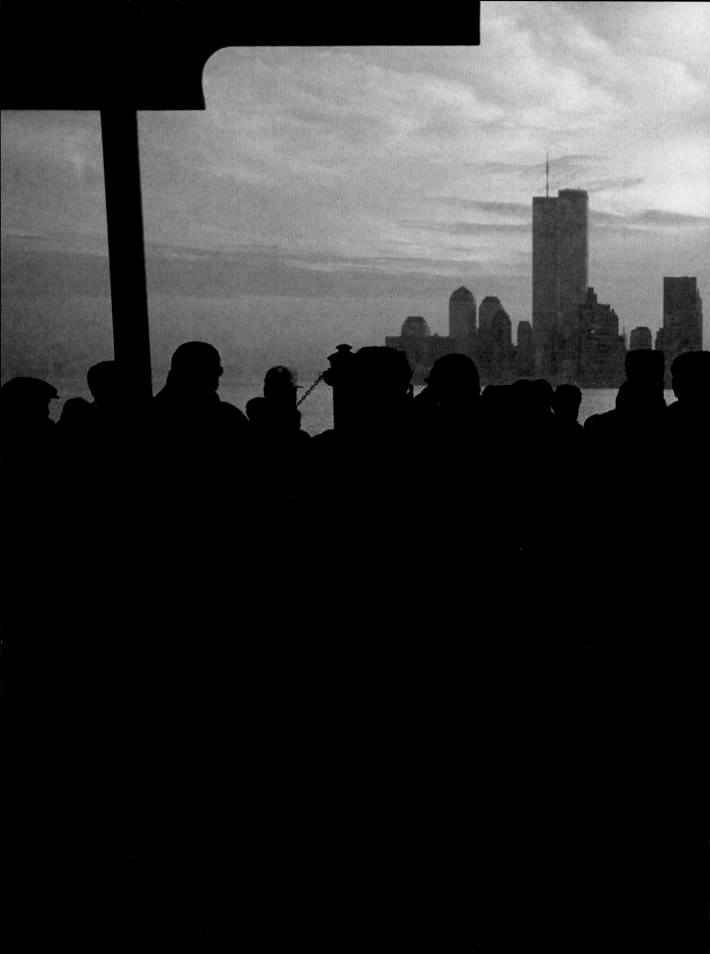

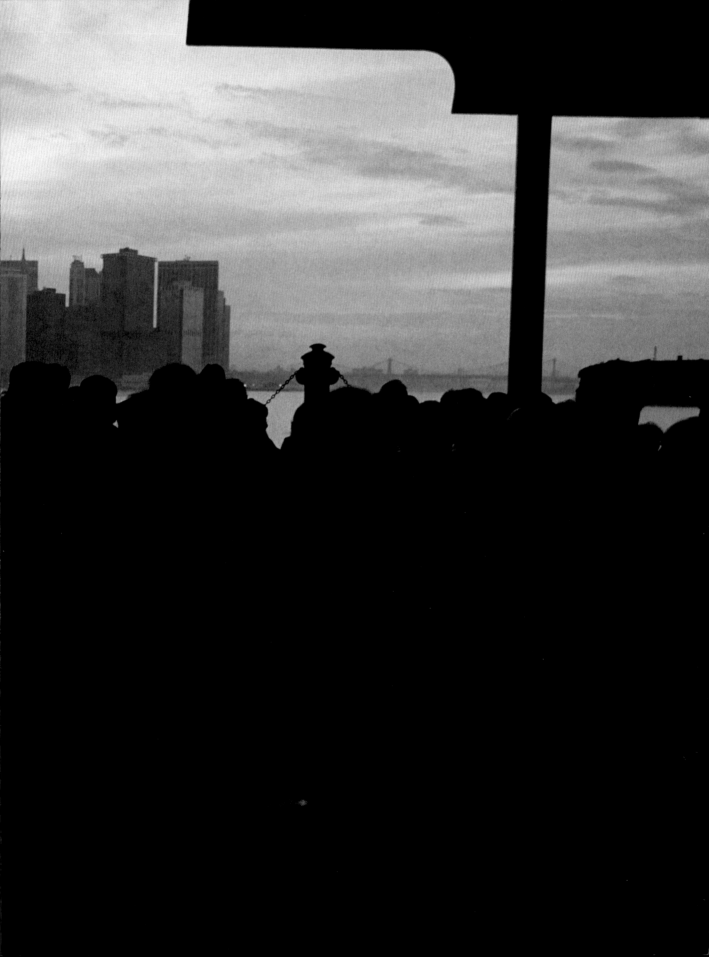

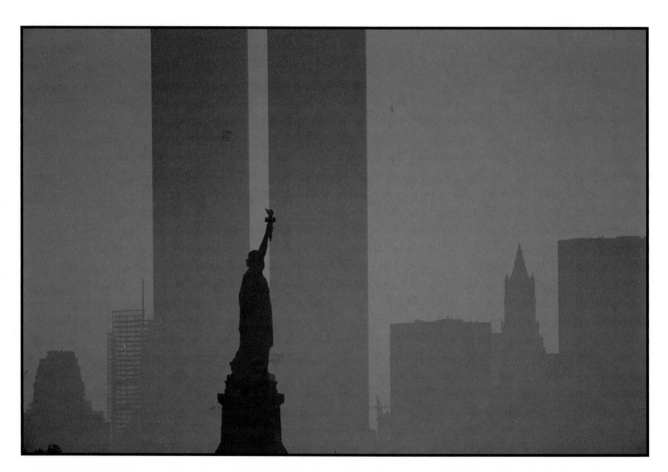

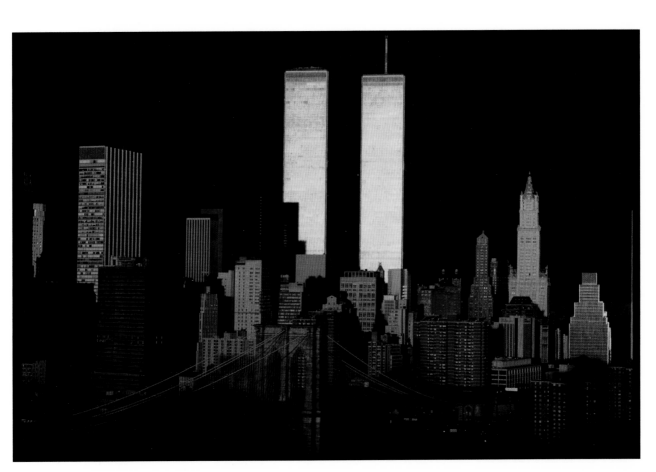

REMEMBER FLYING AROUND THE ICE RINK IN WINTER, THE BULLET-MOTIF OF THE GROUND FLOORS OF THE TOWER FLIPPING BY LIKE A NICKELODEON....THE WINDS WHIPPED SOMETHING FIERCE THERE AT NIGHT. THEY'D BLOW YOUR BODY CLEAR ACROSS THE PLAZA, SPAWN TORNADOES OF NEWSPAPER AND PLASTIC BAGS. AND YOU MIGHT DREAM THAT YOU WERE IN THAT TORNADO, FEEL IT AT MOMENTS, CAUGHT IN ITS CIRCLE LIKE A SPOT-LIGHT, LIFTED FOR AN INSTANT OFF THE GROUND —THEN DREAM OF BEING SUCKED UP IN A RAPTURE AMONG THE BLINKING SQUARES OF LIGHT HIGH BETWEEN THE FLOORS, SHUTTLED UP A PILLAR OF BRAC-ING, TWIRLING AIR. THE MILKY WAY STRETCHED ITS NEBULOUS WAY INSIDE THE BOWL OF THE NIGHT. NEW YORK MADE ITS OWN STARS.

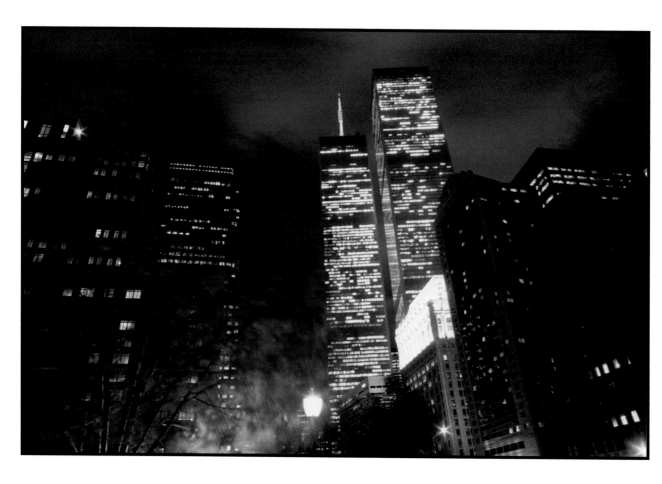

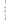

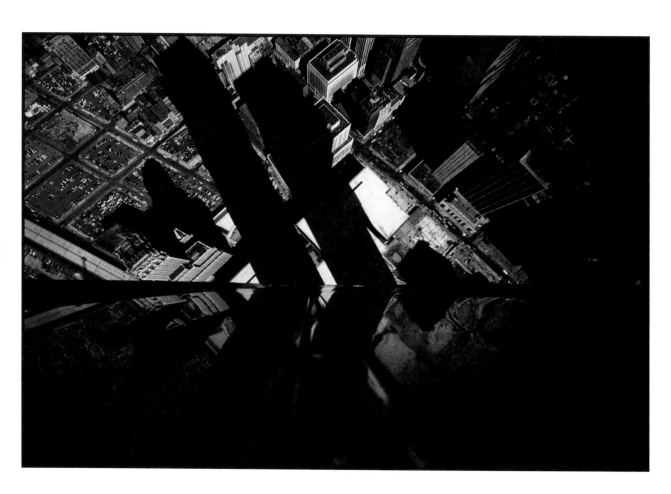

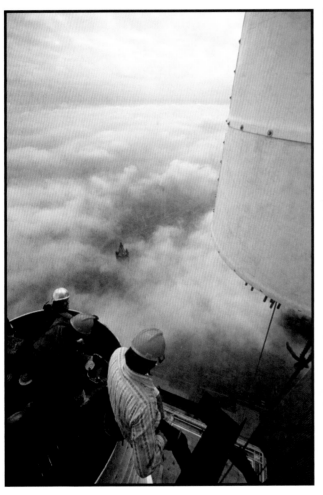

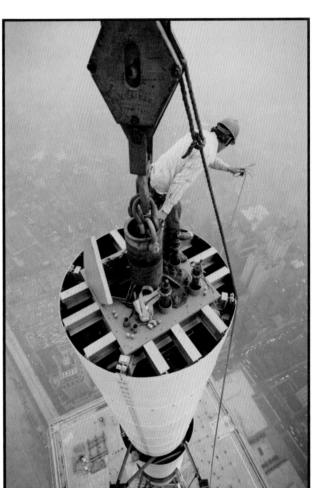

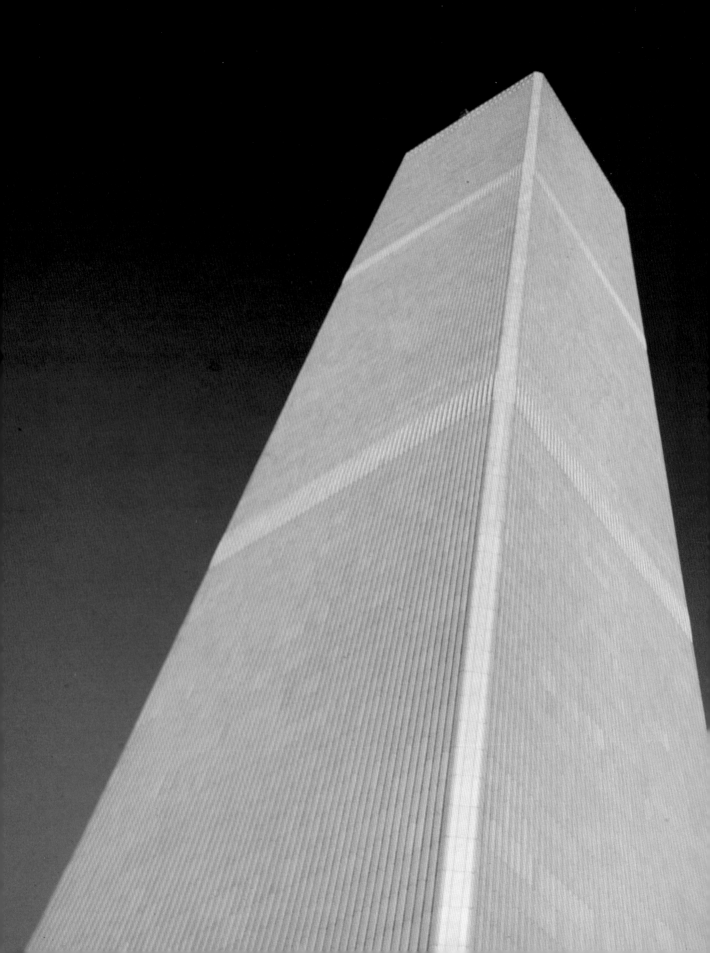

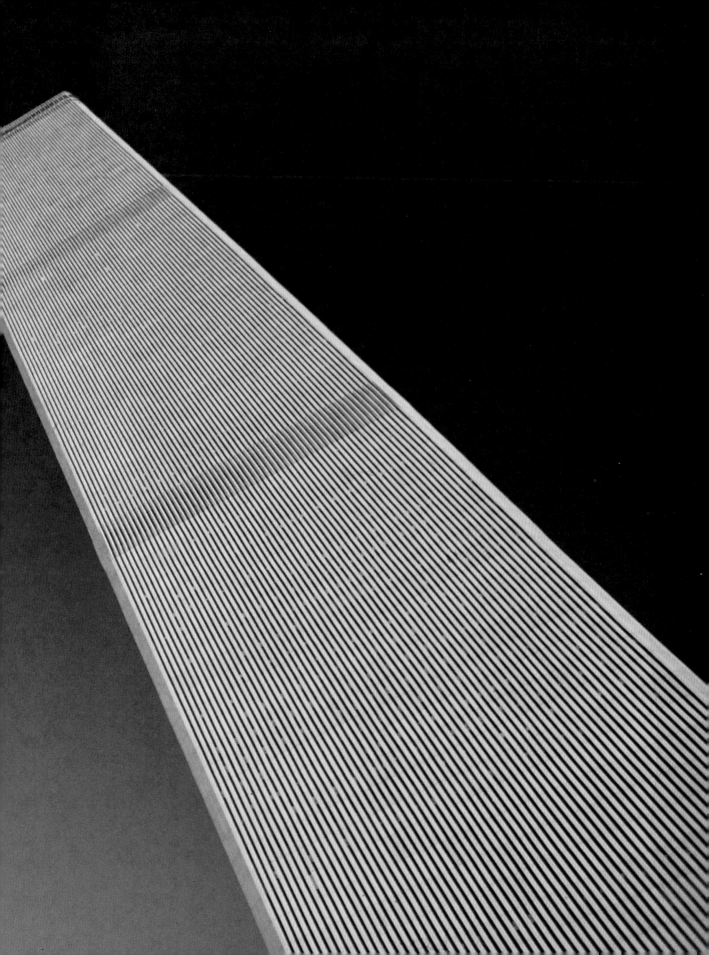

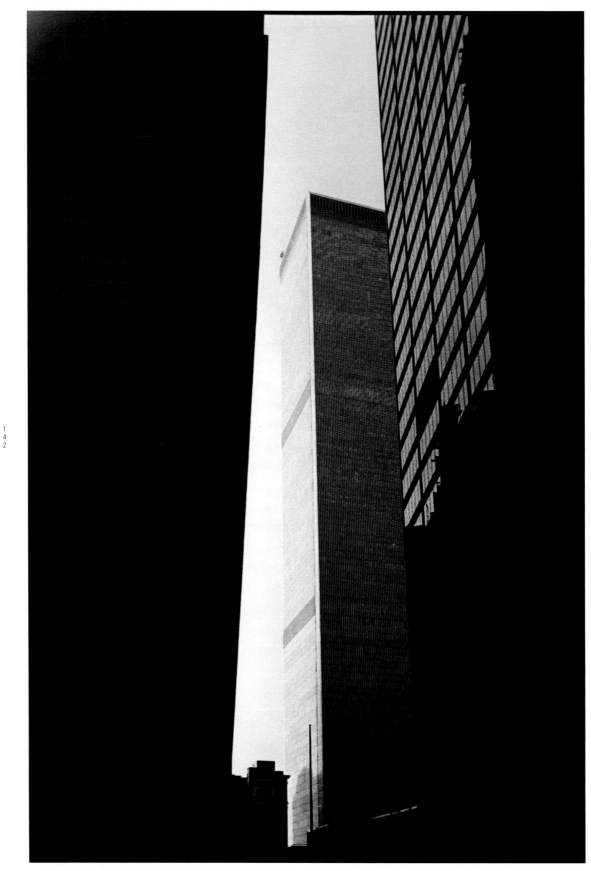

THEY WERE ONLY 28 YEARS OLD, THE TOWERS—YOUNG WHEN YOU THINK ABOUT THEM THAT WAY, AS PEOPLE, AND ALSO A ZENITH OF SORTS, 28, THE VERY BEST OF YEARS, AN OPTIMUM AGE FOR A BOXER OR ANY OTHER SORT OF WARRIOR, THE PINNACLE OF MANHOOD. WHAT WOULD THE WORLD HAVE BEEN LIKE IF ONLY ONE OF THEM HAD FALLEN? OR WAS THAT ALWAYS IMPOSSIBLE—BOUND BY LAWS OF BOTH ENGINEERING AND POETRY.

NOW OLD SCENES POUR OVER THE FLOODLIT EMPTY FIELD, FILLING IT BACK IN… SIPPING A SCOTCH AND WATER AT WINDOWS ON THE WORLD…STANDING AT THE AIRLINE COUNTER IN THE SWEEPING TURN OF THE LOBBY…WATCHING THE RIVER OF BODIES DRAIN OUT OF THE BUILDINGS AT RUSH-HOUR IN A STREAM SO THICK, IT WAS IMPOSSIBLE TO CROSS FROM ONE SIDE OF THE MALL TO THE OTHER. A MILLION INCANDESCENT MOMENTS, SNAPSHOTS, WEDDING ENGAGEMENTS, WRISTWATCHES, A MILLION SUDDENLY FLAMING BEAUTIES…

NOW WE FORGET WHICH STREETS THEY COULD BE SEEN DOWN. NOW, LIKE ABANDONED LOVERS WE THINK WE PICTURE THEM AT THE END OF *ALL* STREETS, GLINTING IN THE SUNSHINE, RISING UP IN CRYSTALLINE MAJESTY.

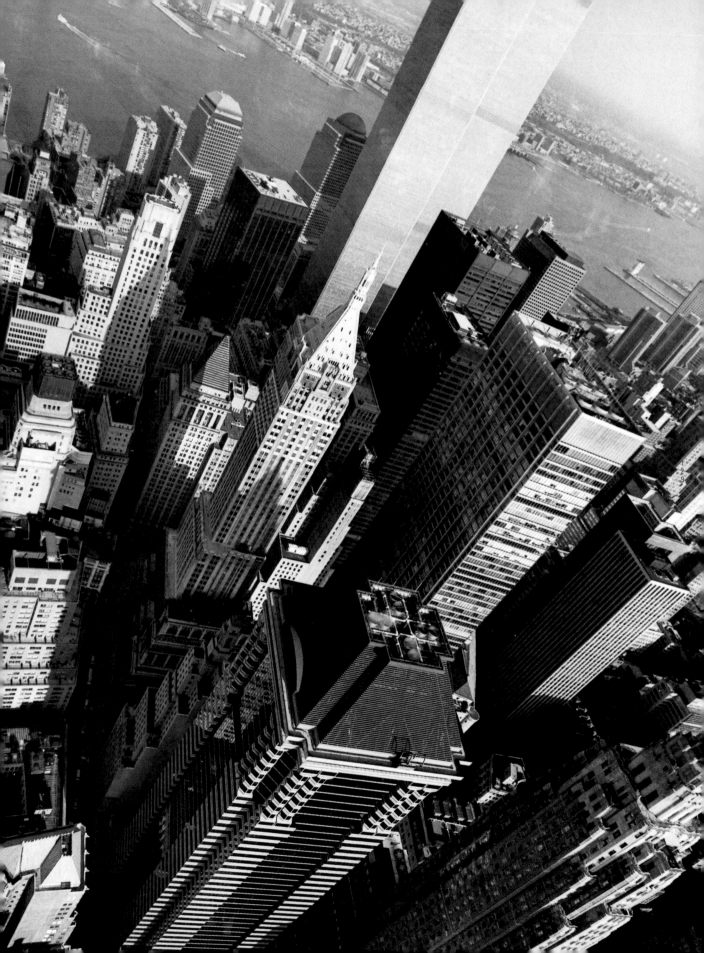

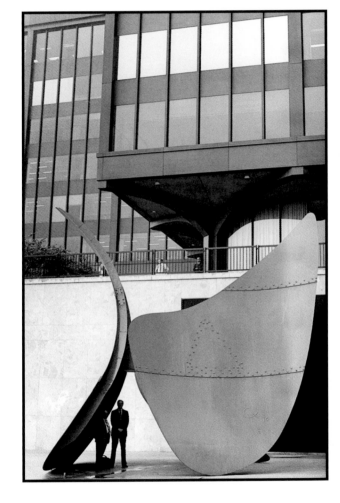

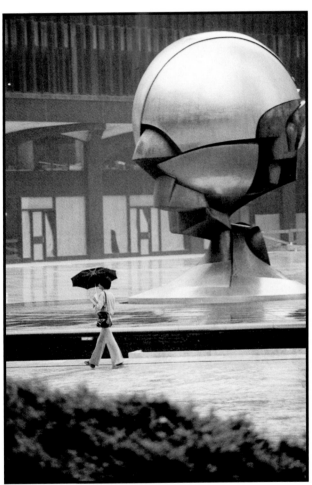

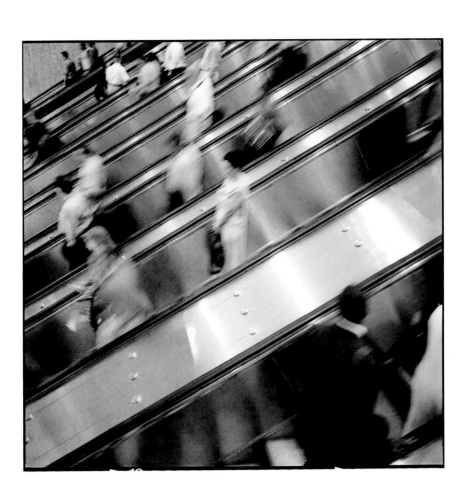

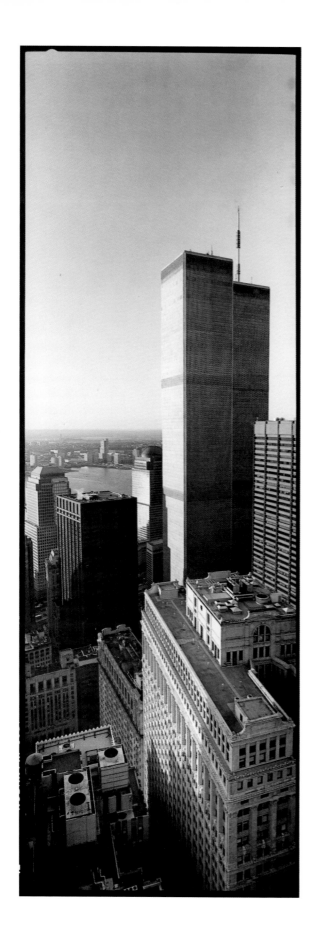

A SYMBOL OF PEACE

NEW YORK IS UNIQUE AMONG THE LARGE CITIES OF THE WORLD; MANHATTAN ITSELF IS AN EVER-CHANGING LANDSCAPE OF BUILDINGS, HIGH AND LOW, A UNIQUE ISLAND WITH A VERY HIGH DENSITY OF POPULATION, BOTH PERMANENT AND COMMUTING. A FEW OF THE BUILDINGS ARE VERY HANDSOME, MOST ARE MEDIOCRE; IN CERTAIN LIGHTS, THE SILHOUETTE OF THE SKYLINE IS VERY BEAUTIFUL, AND EVEN POORLY DESIGNED BUILDINGS BECOME MERGED INTO THE TEXTURE OF THIS FASCINATING CONGLOMERATION OF STRUCTURES SURROUNDED BY WATER. ALTHOUGH AN UNPLANNED EFFECT, AT PARTICULAR TIMES OF THE DAY THIS RESULTS IN ONE OF THE MOST BEAUTIFUL MAN-MADE LANDSCAPES THAT CAN BE SEEN...

MANHATTAN IS, AFTER ALL, A PLACE OF GREAT SCALE THAT MILLIONS OF NEW YORKERS AND VISITORS OVER MANY GENERATIONS HAVE LEARNED TO ENJOY. TO CONVINCE MYSELF THAT THE CONCEPT OF THE HIGH BUILDINGS WAS CORRECT, I PASSED BY, VISITED, AND LOOKED AT THE EMPIRE STATE BUILDING FREQUENTLY OVER A PERIOD OF TIME. THAT EXPERIENCE ASSURED ME THAT ONE BECOMES AS COMFORTABLE STANDING NEXT TO A 100-STORY BUILDING AS ONE FORTY STORIES HIGH; THE WIDTH OF THE STREETS IN THE CITY TENDS TO LIMIT THE VISION OF THE PASSERBY, AND IT IS ONLY THE FIRST-TIME VISITOR WHO CRANES HIS NECK TO SEE THE TOPS OF THE HIGHER BUILDINGS. I DECIDED THAT IN THE DESIGN AND DETAIL OF THE BUILDINGS THAT WE WERE ABOUT TO UNDERTAKE, A MEASURE OF OPENNESS AND TRANSPARENCY WAS APPROPRIATE AT THEIR BASES. WHEN MY ASSOCIATES EXPRESSED THEIR CONCERN THAT THE STRUCTURES MIGHT BE TOO BIG, A COUPLE OF THEM WENT TO STAND NEXT TO AND WALK AROUND THE EMPIRE STATE BUILDING A FEW TIMES, AS I HAD. THEY CAME BACK CONVINCED, AS I WAS, THAT THERE WAS NO DIMINUTION OF THE SOUL, NO ANT-LIKE FEELINGS IN THE FACE OF SUCH A LARGE OBJECT. MAN HAD MADE IT AND COULD COMPREHEND IT, AND ITS PARTS COULD BE UNDERSTOOD TO RELATE TO ITS WHOLE. THERE WAS A WISH AND A NEED TO BE ABLE TO STAND BACK FROM IT, TO SEE AND COMPREHEND ITS HEIGHT, AND WE TRIED TO DO THAT AT THE TRADE CENTER...

DURING THE LONG PERIOD FROM THE GREAT DEPRESSION ON INTO THE EARLY POSTWAR YEARS, THERE WAS LITTLE COMMERCIAL HIGH-RISE CONSTRUCTION IN MANHATTAN. DURING THAT TIME, I AM SURE, INDIVIDUAL PERCEPTIONS OF THE SILHOUETTE OF NEW YORK BECAME FIXED, AND THE GENERAL SKYLINE OF MANHATTAN CAME TO BE THOUGHT OF AS UNCHANGING. AS POSTWAR DEVELOPMENT AND PROSPERITY ENSUED, MANHATTAN AGAIN BECAME THE SITE OF RENEWED CONSTRUCTION ACTIVITY THAT FIRST FOCUSED IN THE MIDTOWN AREA AND THEN SHIFTED DOWNTOWN. NEW TECHNIQUES, ORGANIZATIONS, AND TECHNOLOGIES MANIFESTED THEMSELVES IN THIS INTENSE CONSTRUCTION ACTIVITY, AND THE MANHATTAN SKYLINE WAS NO LONGER THE SAME—THE URBAN DYNAMIC HAD REASSERTED ITSELF AND RESTATED ITS EXCITING PRESENCE. CITIES ARE NOT STATIC ENTITIES; I AM SURE THAT, LIKE THE TRADE CENTER, THE FLATIRON BUILDING, THE WOOLWORTH BUILDING, THE CHRYSLER BUILDING, AND THE EMPIRE STATE BUILDING WERE ALL CRITICIZED FOR BREAKING THE THEN BEAUTIFUL NEW YORK SKYLINE, BUT AS PEOPLE BECAME ACCUSTOMED TO THEM, THEY REALIZED THAT IT IS THE SUCCESSION OF NEW BUILDINGS THAT MAKES MANHATTAN THE UNIQUE AND FASCINATING URBAN CENTER IT IS....**MINORU YAMASAKI**

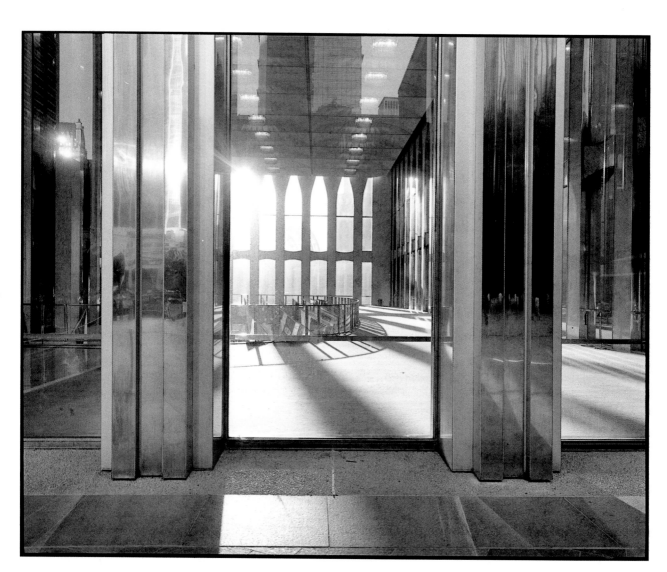

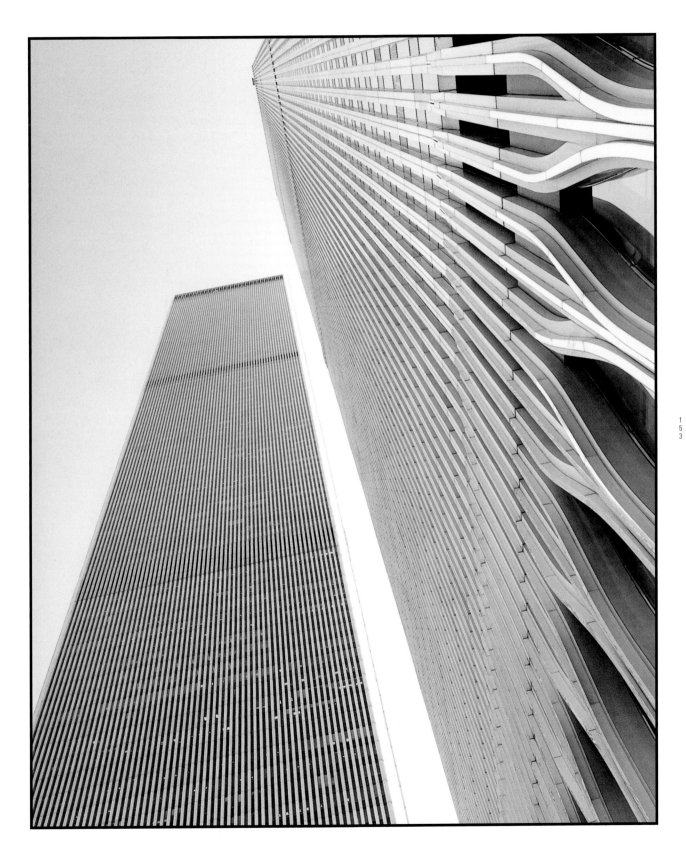

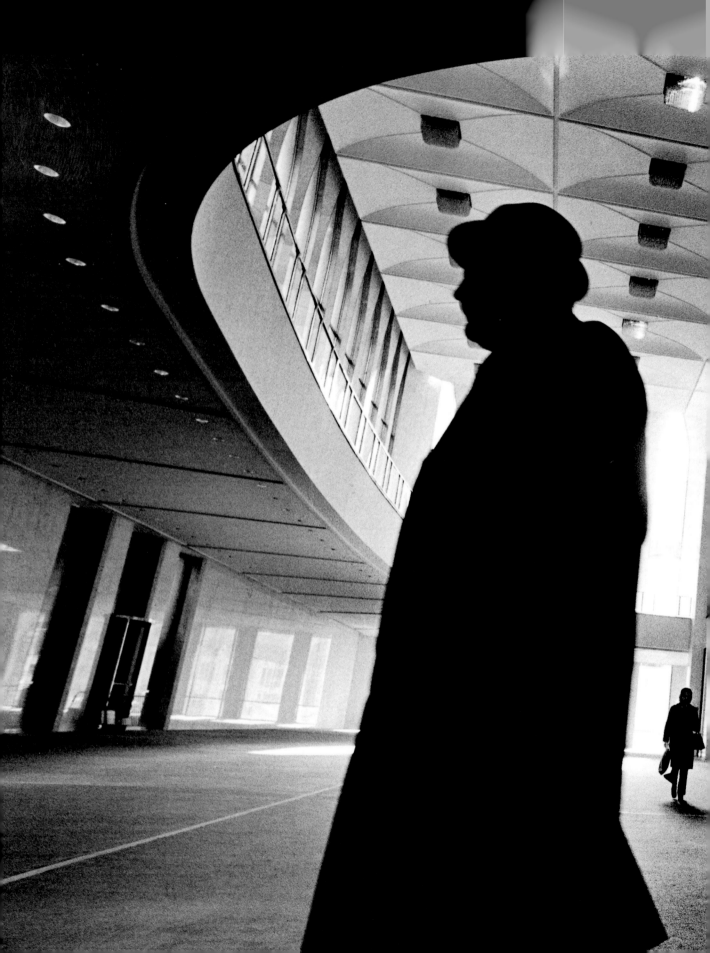

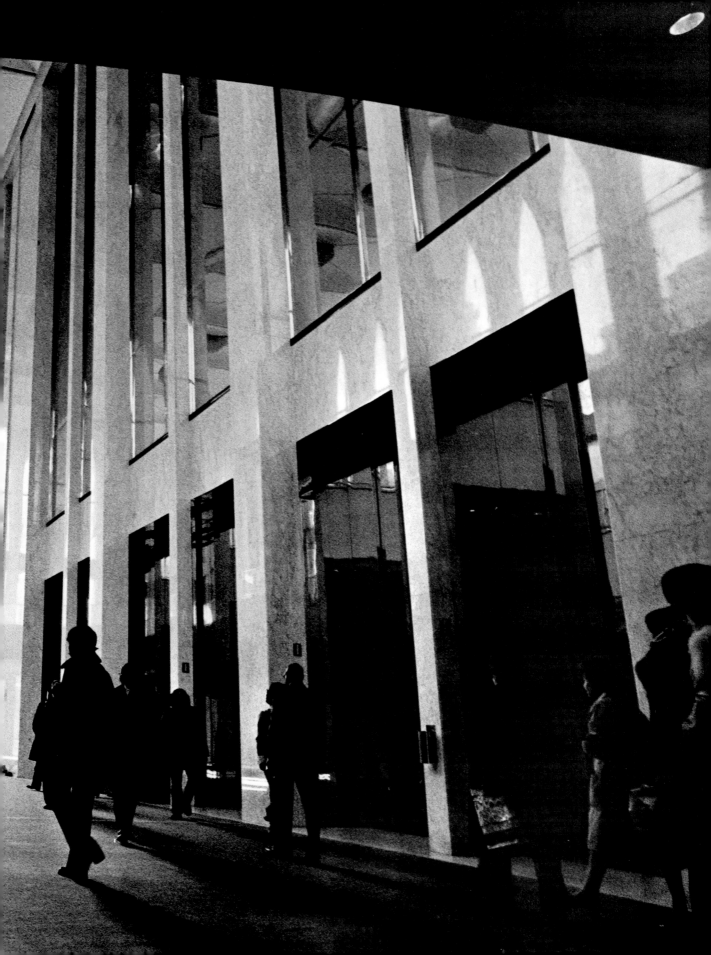

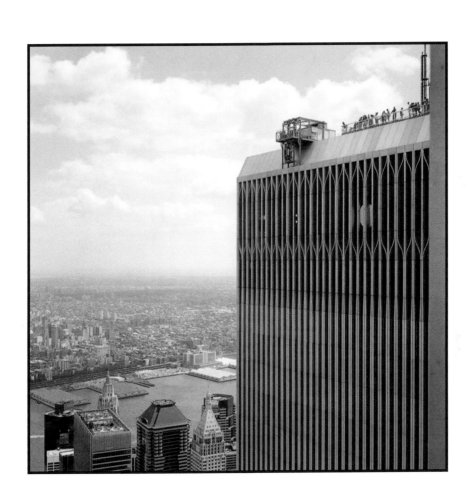

HOW NOT TO REMEMBER SUCH A GLO-RIOUS INDIAN SUMMER MORNING IN NEW YORK CITY WITH ITS CRISP BLUE SKY AND WONDERFULLY MILD TEMPER-ATURE? FEW OF THESE DAYS COME ALONG IN A GIVEN YEAR. FOR WORK REASONS, I HAD CHOSEN NOT TO FLY BACK TO PARIS THE EVENING BEFORE. THE LAST-MINUTE DECISION LEFT ME WITH THE PROSPECT OF A QUIET APPOINTMENT-FREE DAY AHEAD. I REACHED THE AGENCY LATE THAT MORNING, SLIGHTLY AFTER A QUARTER TO NINE, HAVING SPENT A LONG LEISURELY HOUR READING THE *TIMES* AT STARBUCKS ON THE CORNER OF 39TH STREET AND EIGHTH AVENUE. TWO PEOPLE WERE AHEAD OF ME AND ALREADY ON THE PHONE. AS I WALKED IN FIONA TURNED AROUND AND SAID: "A PLANE JUST SMASHED INTO ONE OF THE TOWERS."

CALLS STARTED TO COME IN FROM ALL AROUND THE WORLD: CONCERNED COL-LEAGUES AND FRIENDS DESCRIBING THE HORRIFIC SCENE THEY WERE WATCHING LIVE AND THAT WE COULD NOT SEE OUR-SELVES FROM OUR SEVENTH FLOOR MID-TOWN WINDOWS. NOT UNTIL LATE INTO THE NIGHT, BACK HOME, WERE MY EYES EXPOSED TO THE IMAGES THAT WERE BEING ENDLESSLY REPLAYED ON EVERY TELEVISION STATION: THE PLANES HITTING THE TOWERS; THE GREAT BALLS OF FIRE; THE CRUMBLING OF THE BUILDINGS.

HOWEVER, IT WAS ONLY WHEN LORI GRINKER AND FRANK FOURNIER'S PIC-TURES REACHED OUR LIGHT-BOXES, EARLY THE FOLLOWING MORNING, THAT WE FINALLY PERCEIVED THE FULL MAG-NITUDE OF THE TRAGEDY. THE MINUTE THEY HEARD WHAT HAD HAPPENED THEY BOTH GRABBED THEIR CAMERAS AND FILM, AND HEADED STRAIGHT FOR THE WORLD TRADE CENTER. UNFLINCH-INGLY. FRANK ON HIS BIKE FROM ROOSEVELT ISLAND; LORI BY FOOT, IN SANDALS, AGAINST THE CROWD FLEE-ING OVER THE WILLIAMSBURG BRIDGE. THEY *HAD* TO GO. THEY *HAD* TO BE THERE.

THE PHOTOGRAPHERS I KNOW ARE PEO-PLE OF GREAT CHARACTER, COURAGE AND COMMITMENT. THAT DAY THEY WENT IN WITH THE FIREMEN AND RES-CUE TEAMS. THERE WAS NO ONE LEFT TO RESCUE OR SAVE. DUST WAS EVERY-WHERE, FILLED WITH THE SOULS OF THE DEAD OF SEPTEMBER, DAUGHTERS AND SONS, MOTHERS AND FATHERS, SPOUSES, COMPANIONS, RELATIVES, COLLEAGUES, FRIENDS. ONLY THE PHOTOGRAPHERS COULD STILL *SAVE* ANYTHING.

"I HAVE TO GO. THREE FIREMEN ARE PUT-TING UP A FLAG". LORI ABRUPTLY HUNG UP HER CELL PHONE. JUST LIKE FRANK WOULD A LITTLE LATER. "I HAVE TO GO *NOW*: A FIREMAN IS SCREAMING TO ME TO GET THE HELL OUT OF HERE. WTC 7 IS GOING TO COLLAPSE."

THE PHOTOGRAPHS IN THIS BOOK ARE MEANT TO BE SEEN AND, LIKE THE ACCOMPANYING WORDS BY JACQUES MENASCHE, TONI MORRISON, AND MINORU YAMASAKI, TO BE READ. THEY HELP US TO REMEMBER. TO LOOK AND COPE. TO UNDERSTAND AND POSSIBLY EVEN HEAL. THE POWER OF THOSE LITTLE SQUARES AND RECTANGLES IS BOUNDLESS. THERE ARE ONE HUNDRED AND TEN OF THEM HERE -- ONE FOR EACH OF THE TOWERS HUNDRED AND TEN STORIES. WE FELT A NEED TO ADD OUR OWN "SMALL VOIC-ES" TO THE BROADER TESTIMONIAL OF THE NEW YORK, AMERICAN AND INTER-NATIONAL COMMUNITIES. HENCE THIS MODEST PAPER MEMORIAL.

MINORU YAMASAKI, WHO DIED FIFTEEN YEARS BEFORE THE TWIN TOWERS HE DESIGNED WERE DESTROYED, EXPRESSED HIS PHILOSOPHY OF THEIR INTENT, AND WHAT SHOULD CONTINUE TO BE A GUID-ING PRINCIPLE IN DETERMINING THE FUTURE OF GROUND ZERO: "BEYOND THE COMPELLING NEED TO MAKE THIS A MONUMENT TO WORLD PEACE, THE WORLD TRADE CENTER SHOULD, BECAUSE OF ITS IMPORTANCE, BECOME A REPRESENTATION OF MAN'S BELIEF IN HUMANITY, HIS NEED FOR INDIVIDUAL DIGNITY, HIS BELIEFS IN THE CO-OPERA-TION OF MEN, AND THROUGH CO-OPERA-TION, HIS ABILITY TO FIND GREATNESS".
ROBERT PLEDGE

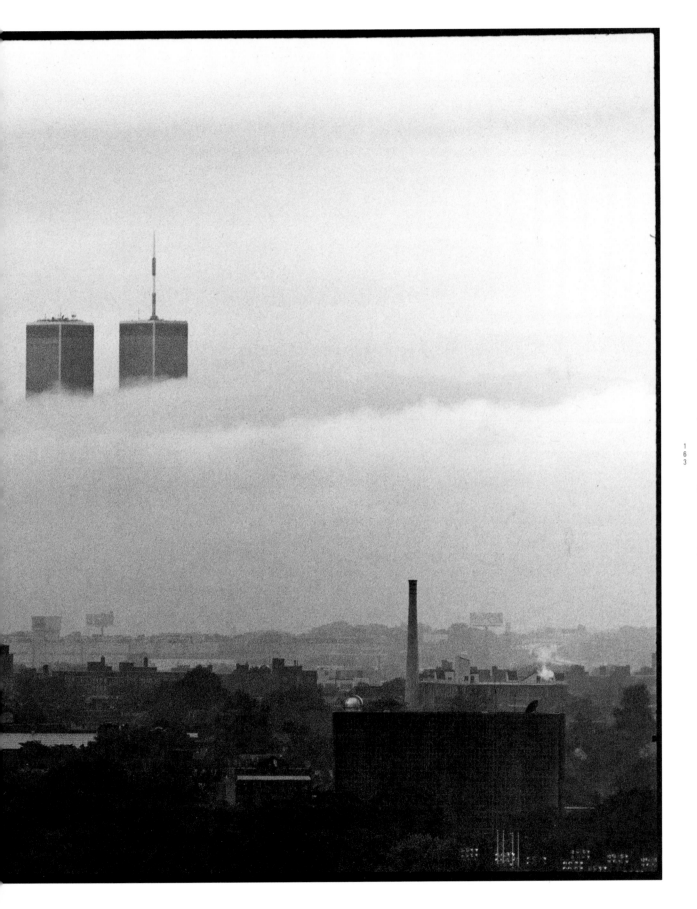

BIOGRAPHIES

JANE EVELYN ATWOOD, AN AMERICAN-BORN DOCUMENTARY PHOTOGRAPHER, IS THE AUTHOR OF FIVE BOOKS, MOST RECENTLY THE DECADE-LONG STUDY, *TOO MUCH TIME: WOMEN IN PRISON* (PHAIDON 2000). SHE HAS LIVED IN PARIS, FRANCE, SINCE 1971.

ZANA BRISKI, A BRITISH-BORN PHOTOG-RAPHER, HAS WORKED EXTENSIVELY IN INDIA, FOCUSING ON SEX WORKERS IN CALCUTTA'S RED-LIGHT DISTRICT. SHE ALSO FOUNDED A PHOTOGRAPHIC WORK-SHOP FOR CHILDREN OF THE PROSTITUTES OF SONAGACHI. SHE LIVES IN NEW YORK CITY, USA.

DAVID BURNETT, AN AMERICAN PHO-TOJOURNALIST, BEGAN HIS CAREER COV-ERING THE VIETNAM WAR FOR *TIME* AND *LIFE* MAGAZINES. HE HAS SINCE WORKED IN NEARLY SEVENTY COUNTRIES AND IS KNOWN FOR HIS IMAGES FROM THE ETHIOPIA FAMINE TO THE IRANIAN REVOLUTION. A CO-FOUNDER OF CONTACT PRESS IMAGES WITH ROBERT PLEDGE, HE LIVES IN WASHINGTON, D.C., USA.

ADGER W. COWANS, AN AMERICAN PHOTOGRAPHER, SPECIALIZES IN MOVIE STILLS AND FINE ART PHOTOGRAPHY. HE LIVES IN NEW YORK CITY, USA.

DEBORAH EDELSTEIN, AN AMERICAN PHOTOGRAPHER AND PICTURE EDITOR, BEGAN HER JOURNALISTIC CAREER AT CONTACT PRESS IMAGES. SHE HAS WORK-ED WITH *NEWSWEEK'S* AND *MEN'S JOURNAL'S* PHOTO DEPARTMENTS. SHE LIVES IN CALIFORNIA, USA.

CHUCK FISHMAN, AN AMERICAN PHO-TOGRAPHER, HAS PRODUCED EXTENSIVE REPORTAGE FROM AROUND THE WORLD, INCLUDING THE RISE OF LECH WALESA AND POLAND'S SOLIDARITY MOVEMENT IN THE 1970'S. HE NOW FREELANCES IN TRAVEL AND CORPORATE PHOTOGRAPHY AND LIVES IN UPSTATE NEW YORK, USA.

FRANK FOURNIER, A FRENCH-BORN PHOTOJOURNALIST, IS KNOWN FOR HIS HUMANIST IMAGERY FROM AROUND THE WORLD, INCLUDING RWANDA, BOS-NIA, COLUMBIA, AND ROMANIA. SINCE 2000 HE HAS BEEN AT WORK ON A MAJOR PROJECT ON HIS ADOPTED HOME OF NEW YORK CITY, USA, WHERE HE HAS LIVED SINCE 1976.

FRED GEORGE, AN AMERICAN PHOTOG-RAPHER, WORKS IN THE FIELDS OF ARCHITECTURE AND ENVIRONMENTAL PORTRAITURE. HE IS THE AUTHOR OF *CHELSEA PIERS, REVITALIZING THE WATER-FRONT* (L'ARCA EDIZIONI 1997). HE LIVES IN NEW YORK CITY, USA.

GIANFRANCO GORGONI, AN ITALIAN PHOTOGRAPHER, IS THE AUTHOR OF *BEYOND THE CANVAS: ARTISTS OF THE SEVENTIES AND EIGHTIES* (RIZZOLI 1985), HIS SEMINAL WORK ON THE CONTEMPO-RARY ART WORLD. HE LIVES IN ITALY AND NEW YORK CITY, USA.

LORI GRINKER, AN AMERICAN PHOTO-JOURNALIST, BEGAN HER CAREER DOCU-MENTING THE RISE OF HEAVYWEIGHT CHAMPION MIKE TYSON. SHE IS THE AUTHOR OF *THE INVISIBLE THREAD* (JPS 1989), AND *AFTER WAR* (DE.MO 2003), A TEN-YEAR PROJECT DOCUMENTING VET-ERANS OF THE CENTURY'S WARS. SHE LIVES IN NEW YORK CITY, USA.

HALE GURLAND, AN AMERICAN ARTIST, PHOTOGRAPHER, AND HELICOPTER PILOT, WELDS LARGE-SIZE SCULPTURES IN METAL AND CONTRIBUTED TO THE RESCUE EFFORT AT GROUND ZERO, CUTTING BEAMS. HE LIVES IN NEW YORK CITY, USA.

SEAN HEMMERLE, AN AMERICAN PHO-TOGRAPHER, SPECIALIZES IN LANDSCAPE AND ARCHITECTURAL PHOTOGRAPHY. HE LIVES IN BROOKLYN, NEW YORK, USA.

KENNETH JARECKE, AN AMERICAN PHOTOJOURNALIST, IS A CONTRACT PHO-TOGRAPHER WITH *U.S. NEWS AND WORLD REPORT* AND AUTHOR OF *JUST ANOTHER WAR* (BEDROCK PRESS 1992). HE LIVES IN MONTANA, USA.

PETER B. KAPLAN, A NATIVE NEW YORKER AND PHOTOGRAPHER, INTERNATIONALLY KNOWN FOR TWO DECADES' OF WORK AND BOOKS ON THE STATUE OF LIBERTY. HE LIVES IN DELAWARE, USA.

JAMES KEYSER, AN AMERICAN PHOTOGRAPHER, FREELANCES IN TRAVEL AND PORTRAITURE PHOTOGRAPHY FOR MANY AMERICAN MAGAZINES. HE LIVES IN NEW YORK CITY, USA.

ANNIE LEIBOVITZ, AN AMERICAN PHOTOGRAPHER, BEGAN HER CAREER AT THE FLEDGLING *ROLLING STONE* IN 1969 AND BECAME CHIEF PHOTOGRAPHER FOR *VANITY FAIR* IN 1983. SHE IS THE AUTHOR OF SIX BOOKS, MOST RECENTLY *WOMEN*, CO-AUTHORED WITH WRITER SUSAN SONTAG (RANDOM HOUSE 1999). SHE LIVES AND WORKS IN NEW YORK CITY, USA.

VINCENT LOPRETO, AN AMERICAN ART DIRECTOR, LIVED AT BATTERY PARK CITY IN NEW YORK UNTIL SHORTLY AFTER SEPTEMBER 11. HE HAS SINCE RELOCATED TO CALIFORNIA, USA.

TIM MAPP, AN AMERICAN PHOTOGRAPHER AND EDITOR, IS A STAFF MEMBER OF CONTACT PRESS IMAGES. A NATIVE OF WISCONSIN, HE LIVES IN BROOKLYN, NEW YORK, USA.

DILIP MEHTA, AN INDIAN PHOTOGRAPHER, KNOWN FOR HIS EXTENSIVE COVERAGE OF ASIAN EVENTS, ISSUES, AND PERSONALITIES, INCLUDING HIS IMAGES OF THE GANDHI FAMILY AND THE BHOPAL DISASTER. HE LIVES IN DELHI, INDIA.

JACQUES MENASCHE, AN AMERICAN-BORN WRITER AND EDITOR, HAS WRITTEN EXTENSIVELY FOR CONTACT PRESS IMAGES SINCE 1999. IN NOVEMBER 2001 HE REPORTED FROM THE WAR IN AFGHANISTAN FOR *THE NEW YORK DAILY NEWS*. HE LIVES IN NEW YORK CITY, USA.

TONI MORRISON, AN AMERICAN NOVELIST, PLAYWRIGHT AND CRITIC, WAS AWARDED THE NOBEL PRIZE IN LITERATURE IN 1993. HER WORKS INCLUDE *THE BLUEST EYE, SULA, TAR BABY, SONG OF SOLOMON,* AND *BELOVED,* WHICH WON THE PULITZER PRIZE FOR FICTION IN 1988. SHE HOLDS THE ROBERT F. GOHEAN PROFESSORSHIP IN THE COUNCIL OF THE HUMANITIES AT PRINCETON UNIVERSITY.

ROBERT PLEDGE, BORN IN ENGLAND AND RAISED IN FRANCE, BEGAN HIS CAREER AS A SPECIALIST IN AFRICAN AFFAIRS. IN 1976 HE CO-FOUNDED CONTACT PRESS IMAGES WITH DAVID BURNETT. HE HAS COMMUTED BETWEEN PARIS, FRANCE, AND NEW YORK CITY, USA, SINCE 1973.

ALON REININGER, AN ISRAELI-BORN PHOTOJOURNALIST, HAS PRODUCED EXTENSIVE REPORTAGE FROM AROUND THE WORLD, PARTICULARLY THE MIDDLE EAST, CHINA, AND CENTRAL AMERICA. HE IS ESPECIALLY KNOWN FOR HIS PIONEERING WORK ON THE AIDS EPIDEMIC IN THE USA AND SOUTHERN AFRICA. HE LIVES IN LOS ANGELES, CALIFORNIA, USA.

JEFFREY D. SMITH, AMERICAN EDITOR AND PICTURE AGENCY DIRECTOR, STARTED AS A FREE-LANCE PHOTOGRAPHER IN 1980. JOINED CONTACT PRESS IMAGES IN 1986. HE LIVES IN NEW YORK CITY, USA.

MINORU YAMASAKI, AN AMERICAN-BORN ARCHITECT OF JAPANESE DESCENT, WAS COMMISSIONED TO DESIGN THE WORLD TRADE CENTER IN 1962. OTHER NOTABLE PROJECTS INCLUDE THE AIR TERMINAL IN DHARAN, SAUDI ARABIA, AND THE CENTURY PLAZA HOTEL IN LOS ANGELES, CALIFORNIA. HE DIED IN 1986.

FUYONG ZHANG, A CHINESE-BORN DANCER, WAS A MEMBER OF CHINA'S CENTRAL BALLET DURING THE CULTURAL REVOLUTION AND ALSO THE COMPANY PHOTOGRAPHER. IN 1990 HE EMIGRATED TO NEW YORK CITY, USA.

TIM ZIELENBACH, AN AMERICAN PHOTOJOURNALIST, WORKED EXTENSIVELY IN SOUTH AFRICA. HE LIVES IN TEXAS AND WORKS FOR THE DAILY *MARSHALL NEWS-MESSENGER.*

DEBORAH EDELSTEIN
FROM WORLD TRADE
CENTER PLAZA
AUGUST 1980
© DEBORAH EDELSTEIN

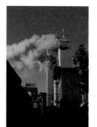

ADGER W. COWANS
FROM WEST BROADWAY
AND DUANE STREET;
PLANE HITTING
SOUTH TOWER
SEPTEMBER 11, 2001
© ADGER W. COWANS

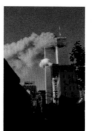

ADGER W. COWANS
FROM WEST BROADWAY
AND DUANE STREET;
PLANE HITTING
SOUTH TOWER
SEPTEMBER 11, 2001
© ADGER W. COWANS

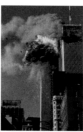

ADGER W. COWANS
FROM WEST BROADWAY
AND DUANE STREET;
PLANE HITTING
SOUTH TOWER
SEPTEMBER 11, 2001
© ADGER W. COWANS

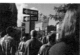

JAMES KEYSER
FROM EIGHTH AVENUE,
GREENWICH VILLAGE
SEPTEMBER 11, 2001
© JAMES KEYSER

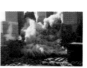

SEAN HEMMERLE
FROM THE JERSEY CITY
PROMENADE, NJ
SEPTEMBER 11, 2001
© SEAN HEMMERLE

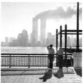

VINCENT LOPRETO
SOUTH TOWER COLLAPSE,
BATTERY PARK CITY,
CORNER OF VESEY STREET
AND NORTH END AVENUE
SEPTEMBER 11, 2001
© VINCENT LOPRETO

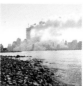

SEAN HEMMERLE
SOUTH TOWER COLLAPSE,
FROM THE JERSEY CITY
PROMENADE, NJ
SEPTEMBER 11, 2001
© SEAN HEMMERLE

CREDITS

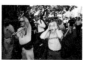

TIM MAPP
NORTH TOWER COLLAPSE,
SIXTH AVENUE,
GREENWICH VILLAGE
SEPTEMBER 11, 2001
© TIM MAPP

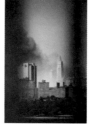

LORI GRINKER
FROM WILLIAMSBURG
BRIDGE: NORTH TOWER
BURNING AFTER COLLAPSE
OF SOUTH TOWER.
SEPTEMBER 11, 2001
© LORI GRINKER

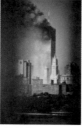

LORI GRINKER
FROM WILLIAMSBURG
BRIDGE AFTER NORTH
TOWER COLLAPSE
SEPTEMBER 11, 2001
© LORI GRINKER

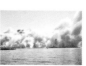

SEAN HEMMERLE
FROM THE JERSEY CITY
PROMENADE, NJ AFTER
NORTH TOWER COLLAPSE
SEPTEMBER 11, 2001
© SEAN HEMMERLE

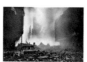

FRANK FOURNIER
NEAR THE CORNER
OF GREENWICH AND
LIBERTY STREET
SEPTEMBER 11, 2001
© FRANK FOURNIER

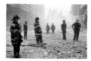

FRANK FOURNIER
ONE LIBERTY PLAZA AFTER
THE COLLAPSE OF TOWERS
SEPTEMBER 11, 2001
© FRANK FOURNIER

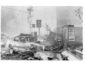

FRANK FOURNIER
CORTLANDT STREET NEAR
CHURCH STREET
SEPTEMBER 11, 2001
© FRANK FOURNIER

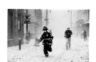

LORI GRINKER
NASSAU STREET
SEPTEMBER 11, 2001
© LORI GRINKER

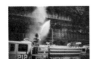

FRANK FOURNIER
WORLD TRADE CENTER 5
SEPTEMBER 11, 2001
© FRANK FOURNIER

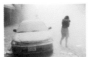

LORI GRINKER
FULTON STREET
SEPTEMBER 11, 2001
© LORI GRINKER

ZANA BRISKI
BROADWAY, NEAR
VESEY STREET
SEPTEMBER 11, 2001
© ZANA BRISKI

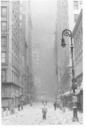

FRANK FOURNIER
NASSAU STREET
SEPTEMBER 11, 2001
© FRANK FOURNIER

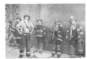

FRANK FOURNIER
IN FRONT OF CENTURY 21
ON CORTLANDT STREET
SEPTEMBER 11, 2001
© FRANK FOURNIER

LORI GRINKER
SIDE STREET EAST
OF BROADWAY
SEPTEMBER 11, 2001
© LORI GRINKER

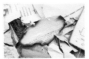

LORI GRINKER
SIDE STREET EAST
OF BROADWAY
SEPTEMBER 11, 2001
© LORI GRINKER

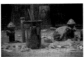

LORI GRINKER
SIDE STREET EAST
OF BROADWAY
SEPTEMBER 11, 2001
© LORI GRINKER

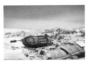

TIM ZIELENBACH
NEAR GROUND ZERO
SEPTEMBER 12, 2001
© TIM ZIELENBACH

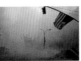

FRANK FOURNIER
IN FRONT OF CENTURY 21,
CHURCH STREET
SEPTEMBER 11, 2001
© FRANK FOURNIER

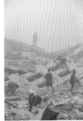

FRANK FOURNIER
AT GROUND ZERO
SEPTEMBER 11, 2001
© FRANK FOURNIER

LORI GRINKER
TWO WORLD
FINANCIAL CENTER
SEPTEMBER 11, 2001
© LORI GRINKER

LORI GRINKER
FROM TWO WORLD
FINANCIAL CENTER:
RAISING THE AMERICAN
FLAG AT GROUND ZERO
SEPTEMBER 11, 2001
© LORI GRINKER

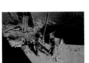

LORI GRINKER
FROM TWO WORLD
FINANCIAL CENTER:
RAISING THE AMERICAN
FLAG AT GROUND ZERO
SEPTEMBER 11, 2001
© LORI GRINKER

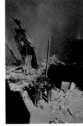

LORI GRINKER
FROM TWO WORLD
FINANCIAL CENTER:
RAISING THE AMERICAN
FLAG AT GROUND ZERO
SEPTEMBER 11, 2001
© LORI GRINKER

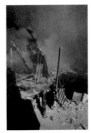

LORI GRINKER
FROM TWO WORLD
FINANCIAL CENTER:
RAISING THE AMERICAN
FLAG AT GROUND ZERO
SEPTEMBER 11, 2001
© LORI GRINKER

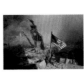

LORI GRINKER
FROM TWO WORLD
FINANCIAL CENTER:
RAISING THE AMERICAN
FLAG AT GROUND ZERO
SEPTEMBER 11, 2001
© LORI GRINKER

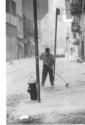

LORI GRINKER
SIDE STREET EAST
OF BROADWAY
SEPTEMBER 11, 2001
© LORI GRINKER

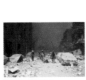

FRANK FOURNIER
GREENWICH STREET
SEPTEMBER 11, 2001
© FRANK FOURNIER

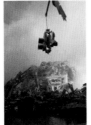

LORI GRINKER
INCINERATED TRAFFIC
LIGHT ON WEST STREET
SEPTEMBER 11, 2001
© LORI GRINKER

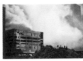

LORI GRINKER
LOOKING AT GROUND ZERO
FROM MURRAY STREET
SEPTEMBER 11, 2001
© LORI GRINKER

ZANA BRISKI
BROADWAY AND
LIBERTY STREET
SEPTEMBER 13, 2001
© ZANA BRISKI

ZANA BRISKI
SPARROW ON THE
CORNER OF WEST STREET
AND BROADWAY
SEPTEMBER 11, 2001
© ZANA BRISKI

ZANA BRISKI
ST. PAUL'S CEMETERY,
CHURCH STREET
SEPTEMBER 13, 2001
© ZANA BRISKI

ZANA BRISKI
VESEY STREET NEAR
GROUND ZERO
SEPTEMBER 13, 2001
© ZANA BRISKI

ZANA BRISKI
IN FRONT OF THE
MILLENNIUM HOTEL,
CHURCH STREET
SEPTEMBER 13, 2001
© ZANA BRISKI

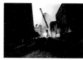

ZANA BRISKI
WORLD TRADE CENTER
REMAINS AT NIGHT
SEPTEMBER 13, 2001
© ZANA BRISKI

ZANA BRISKI
POINTING TOWARD
GROUND ZERO
SEPTEMBER 13, 2001
© ZANA BRISKI

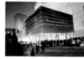

ZANA BRISKI
WORLD TRADE CENTER 5
SEPTEMBER 13, 2001
© ZANA BRISKI

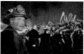

FRED GEORGE
FIREFIGHTERS AND
RESCUE WORKERS AT
GROUND ZERO
SEPTEMBER 13, 2001
© FRED GEORGE

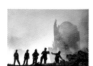

FRED GEORGE
FIREFIGHTERS AND
RESCUE WORKERS AT
GROUND ZERO
SEPTEMBER 12, 2001
© FRED GEORGE

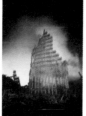

HALE GURLAND
REMAINS OF THE WORLD
TRADE CENTER
BETWEEN SEPTEMBER 12
AND 15, 2001
© HALE GURLAND

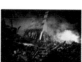

HALE GURLAND
REMAINS OF THE WORLD
TRADE CENTER
BETWEEN SEPTEMBER 12
AND 15, 2001
© HALE GURLAND

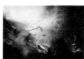

HALE GURLAND
A CRANE HELPING RESCUE
EFFORTS AT GROUND ZERO
BETWEEN SEPTEMBER 12
AND 15, 2001
© HALE GURLAND

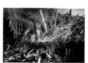

HALE GURLAND
DEBRIS AT GROUND ZERO
SEPTEMBER 12, 2001
© HALE GURLAND

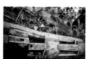

HALE GURLAND
WORLD TRADE
CENTER WRECKAGE
BETWEEN SEPTEMBER 12
AND 15, 2001
© HALE GURLANDI

HALE GURLAND
FIREFIGHTERS AND
RESCUE WORKERS AT
GROUND ZERO
BETWEEN SEPTEMBER 12
AND 15, 2001
© HALE GURLAND

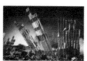

HALE GURLAND
REMAINS OF THE WORLD
TRADE CENTER
BETWEEN SEPTEMBER 12
AND 15, 2001
© HALE GURLAND

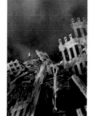

SEAN HEMMERLE
REMAINS OF THE WORLD
TRADE CENTER
SEPTEMBER 13, 2001
© SEAN HEMMERLE

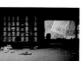

SEAN HEMMERLE
INTERIOR OF THE BROOKS
BROTHER'S STORE,
SHOWING GROUND ZERO
SEPTEMBER 13, 2001
© SEAN HEMMERLE

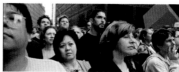

JANE EVELYN ATWOOD
PEOPLE STARE AT THE
WORLD TRADE CENTER
DISASTER SITE
SEPTEMBER 29, 2001
© JANE EVELYN ATWOOD

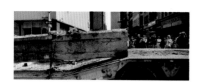

AANE EVELYN ATWOOD
REMOVAL OF DEBRIS FROM
THE WORLD TRADE CENTER
CHURCH STREET
SEPTEMBER 26, 2001
© JANE EVELYN ATWOOD

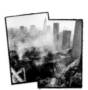

ANNIE LEIBOVITZ
GROUND ZERO FROM
SOUTHWESTERN CORNER
SEPTEMBER 26, 2001
© ANNIE LEIBOVITZ

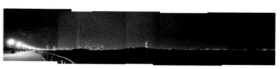

SEAN HEMMERLE
TRIBUTE IN LIGHT, STATUE
OF LIBERTY, AND THE
VERRAZANO-NARROWS
BRIDGE (L. TO R.)
MARCH, 11, 2002
© SEAN HEMMERLE

LORI GRINKER
AERIAL VIEW FROM
THE SOUTH
MARCH 1999
© LORI GRINKER

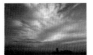

KENNETH JARECKE
VIEW FROM THE STATEN
ISLAND FERRY
MARCH 1990
© KENNETH JARECKE

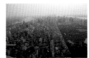

GIANFRANCO GORGONI
VIEW FROM THE NORTH,
WITH CENTRAL PARK
JUNE 1982
© GIANFRANCO GORGONI

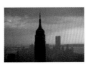

DAVID BURNETT
AERIAL VIEW FROM
THE EMPIRE STATE
BUILDING
JANUARY 1975
© DAVID BURNETT

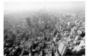

DILIP MEHTA
VIEW FROM THE
NORTH, WITH THE
EMPIRE STATE BUILDING
APRIL 1986
© DILIP MEHTA

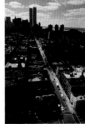

GIANFRANCO GORGONI
VIEW SOUTH FROM
HOUSTON STREET
AND BROADWAY
MARCH 1981
© GIANFRANCO GORGONI

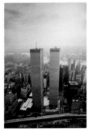

DAVID BURNETT
EASTERN AERIAL VIEW OF
THE WORLD TRADE CENTER
JULY 1974
© DAVID BURNETT

CHUCK FISHMAN
WORLD TRADE CENTER
FROM THE STATEN
ISLAND FERRY
APRIL 1980
© CHUCK FISHMAN

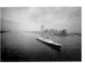

PETER B. KAPLAN
WORLD TRADE CENTER
FROM THE STATUE
OF LIBERTY
FALL 1982
© PETER B. KAPLAN

DAVID BURNETT
WORLD TRADE CENTER
FROM THE SOUTH,
SHOWING THE FINAL
TRANSATLANTIC VOYAGE
OF THE SS FRANCE WHICH
REACHED FRANCE ON
SEPTEMBER 11, 1974.
© DAVID BURNETT

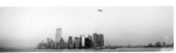

FRED GEORGE
SOUTHERN VIEW OF
MANHATTAN FROM THE
STATEN ISLAND FERRY
NOVEMBER 12, 1999
© FRED GEORGE

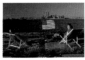

DILIP MEHTA
WORLD TRADE CENTER
FROM STATEN ISLAND
JULY 4, 1986
© DILIP MEHTA

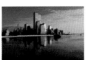

FRANK FOURNIER
WORLD TRADE CENTER
AND HUDSON RIVER
DURING WINTER
JANUARY 2001
© FRANK FOURNIER

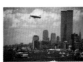

DAVID BURNETT
SOUTHERN VIEW OF
WORLD TRADE CENTER
AND NEW YORK HARBOR
JULY 4, 1986
© DAVID BURNETT

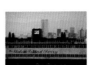

CHUCK FISHMAN
STATEN ISLAND
FERRY AND WORLD
TRADE CENTER
MARCH 1980
© CHUCK FISHMAN

PETER B. KAPLAN
SOUTHERN VIEW OF THE
NORTH TOWER
1983
© PETER B. KAPLAN

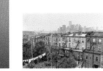

KENNETH JARECKE
EASTERN VIEW OF
LOWER MANHATTAN
FROM BROOKLYN
AUGUST 1990
© KENNETH JARECKE

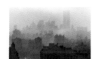

ALON REININGER
WORLD TRADE CENTER
FROM THE EMPIRE
STATE BUILDING
NOVEMBER 1975
© ALON REININGER

KENNETH JARECKE
WORLD TRADE CENTER
AND NEW YORK CITY
FROM STATEN ISLAND
MARCH 1990
© KENNETH JARECKE

DAVID BURNETT
WORLD TRADE CENTER
AND NEW YORK CITY,
IN SILHOUETTE FROM
THE EAST
OCTOBER 1982
© DAVID BURNETT

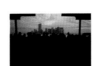

KENNETH JARECKE
SOUTHERN VIEW OF
MANHATTAN FROM THE
STATEN ISLAND FERRY
MARCH 1990
© KENNETH JARECKE

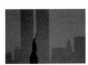

DILIP MEHTA
WORLD TRADE CENTER
FROM THE SOUTH, WITH
THE STATUE OF LIBERTY
JULY 1986
© DILIP MEHTA

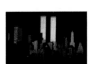

PETER B. KAPLAN
WORLD TRADE CENTER
FROM THE TOP OF THE
MANHATTAN BRIDGE
OCTOBER 1979
© PETER B. KAPLAN

PETER B. KAPLAN
WORLD TRADE CENTER
FROM THE SOUTH, WITH
THE EMPIRE STATE AND
CHRYSLER BUILDINGS
FALL 1986
© PETER B. KAPLAN

FRANK FOURNIER
WORLD TRADE CENTER
FROM THE WEST SIDE OF
LOWER MANHATTAN
NOVEMBER 1994
© FRANK FOURNIER

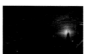

PETER B. KAPLAN
DOUBLE EXPOSURE OF THE
WORLD TRADE CENTER
1982
© PETER B. KAPLAN

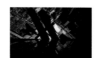

PETER B. KAPLAN
SHADOW OF THE TWIN
TOWERS SEEN FROM THE
TOP OF THE NORTH TOWER
MARCH 1974
© PETER B. KAPLAN

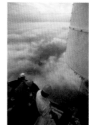

PETER B. KAPLAN
INSTALLING THE
ANTENNA TO THE TOP
OF THE NORTH TOWER,
WITH THE WOOLWORTH
BUILDING SEEN BELOW
MAY 1979
© PETER B. KAPLAN

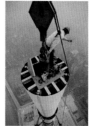

PETER B. KAPLAN
INSTALLING THE
ANTENNA TO THE TOP
OF THE NORTH TOWER
MAY 1979
© PETER B. KAPLAN

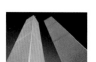

DAVID BURNETT
THE TWIN TOWERS
FROM WORLD TRADE
CENTER PLAZA
JULY 1974
© DAVID BURNETT

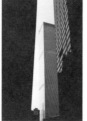

ALON REININGER
WORLD TRADE CENTER
FROM LOWER MANHATTAN
NOVEMBER 1975
© ALON REININGER

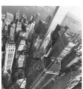

FRED GEORGE
AERIAL VIEW OF LOWER
MANHATTAN FROM
THE SOUTHEAST
OCTOBER 13, 1999
© FRED GEORGE

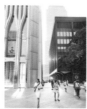

SEAN HEMMERLE
WORLD TRADE
CENTER PLAZA
JUNE 2001
© SEAN HEMMERLE

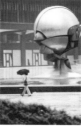

ALON REININGER
SCULPTURE BY FRITZ
KOENIG ON THE WORLD
TRADE CENTER PLAZA
AUGUST 1977
© ALON REININGER

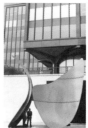

ALON REININGER
SCULPTURE BY ALEXANDER
CALDER ON THE WORLD
TRADE CENTER PLAZA
AUGUST 1977
© ALON REININGER

ALON REININGER
TWIN TOWERS FROM
THE WORLD TRADE
CENTER PLAZA
MAY 1982
© ALON REININGER

SEAN HEMMERLE
ESCALATORS TO THE PATH
TRAINS BENEATH THE
WORLD TRADE CENTER
AUGUST 2001
© SEAN HEMMERLE

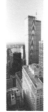

FRED GEORGE
EASTERN AERIAL VIEW OF
THE WORLD TRADE CENTER
OCTOBER 13, 1999
© FRED GEORGE

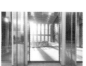

SEAN HEMMERLE
NORTH TOWER,
MEZZANINE LEVEL
JUNE 2001
© SEAN HEMMERLE

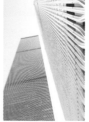

SEAN HEMMERLE
TWIN TOWERS
FROM WORLD TRADE
CENTER PLAZA
JUNE 2001
© SEAN HEMMERLE

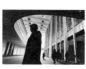

ALON REININGER
SOUTH TOWER LOBBY
NOVEMBER 1975
© ALON REININGER

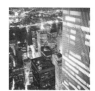

SEAN HEMMERLE
THE SOUTH TOWER SEEN
AT NIGHT FROM "BEST
BAR IN THE WORLD" IN
THE NORTH TOWER.
JUNE 2001
© SEAN HEMMERLE

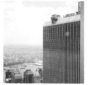

SEAN HEMMERLE
THE SOUTH TOWER AND
OBSERVATION DECK
SEEN FROM "BEST BAR
IN THE WORLD" IN THE
NORTH TOWER
JUNE 2001
© SEAN HEMMERLE

PETER B. KAPLAN
SUNSET AND
TWIN TOWERS
1981
© PETER B. KAPLAN

FUYONG ZHANG
WORLD TRADE CENTER
SEEN FROM QUEENS
JUNE 13, 1998
© FUYONG ZHANG

ACKNOWLEDGMENTS

THIS BOOK IS THE RESULT OF THE GEN-EROUS EFFORTS AND HARD WORK OF MANY PEOPLE. OUR DEEP GRATITUDE TO:

THE EDITORIAL STAFF OF CONTACT PRESS IMAGES IN NEW YORK, NOTABLY DIGITAL SERVICES DIRECTOR TIM MAPP WHO JUG-GLED SEVERAL ROLES, ALL WHILE KEEPING THE PHOTOGRAPHIC AND TECHNICAL GREM-LINS IN CHECK, AND EXECUTIVE DIRECTOR JEFFREY D. SMITH WHO HELPED TO CON-CEIVE THE BOOK'S TITLE AND ASSISTED ALL ALONG WITH THE PROJECT'S PRODUC-TION WHILE CONTINUING TO FOCUS ON THE AGENCY'S DAY-TO-DAY ACTIVITIES WITH EDITOR GREG SAUTER. BERNICE KOCH, CATHERINE PLEDGE AND AUDREY JONES, WHO, WITH THE ASSISTANCE OF SOPHIE BRAVET, FIONA MCKASKIE, AND NANCY KOCH FACILITATED THE SMOOTH RUNNING OF THE OFFICE WHILE ATTENTIONS WERE DIVERTED TO THIS BOOK PROJECT. THE STRONG ESPRIT DE CORPS AND COOPER-ATION OF THE PARIS STAFF OF CONTACT PRESS IMAGES, DOMINIQUE DESCHA-VANNE AND FRANCK SEGUIN, WHICH HELPED IMMEASURABLY DURING LONG DAYS AND NIGHTS, AS DID THE DEDICA-TION OF NEW YORK INTERNS, SAMANTHA BOX AND SOPHIE TASSON.

JOHN KLOTNIA AND ABBY BENNETT AT OPTO DESIGN FOR THEIR INSIGHT AND CREATIVITY; LITERARY AGENT SARAH LAZIN FOR HER UNFLAGGING SUPPORT OF THIS PROJECT; PETER WANG OF REDSTONE FOR HIS TECHNICAL EXPERTISE; AND CHARLES MIERS, JANE GINSBERG, AND REBECCA CREMONESE AT UNIVERSE PUBLISHING/ RIZZOLI INTERNATIONAL FOR THEIR UN-COMPROMISING BELIEF IN THIS BOOK AS A PHOTOGRAPHIC AND TEXTUAL MEMORIAL. THE PRINTING STAFF AND CREW AT PHOENIX COLOR IN ROCKAWAY, NEW JERSEY FOR THEIR DILIGENCE AND ATTEN-TION TO DETAIL.

KEN NORWICK, LAW PARTNER OF OUR FRIEND AND ATTORNEY THE LATE TENNYSON SCHAD, WHO LENT HIS THOUGHTFUL AND VALUED COUNSEL AT VARIOUS STAGES OF THIS BOOK.

JACQUES MENASCHE FOR HIS INVALU-ABLE ASSISTANCE TO PHOTOGRAPHERS AT GROUND ZERO ON SEPTEMBER 11, AND WHO PROVIDED HIS MOVING FIRST-HAND ACCOUNT OF THE ATTACK AND WAS INVOLVED IN THIS PROJECT AT EVERY LEVEL; TONI MORRISON FOR HER BEAU-TIFUL AND HEART-WRENCHING ELEGY AND THE SPIRIT WITH WHICH SHE GEN-EROUSLY PROVIDED IT TO US. WITH RESPECT, WE ALSO ACKNOWLEDGE THE CONTRIBUTION OF WORLD TRADE CEN-TER ARCHITECT MINORU YAMASAKI.

CAPTAIN JOHN VIGIANO (RET.) OF THE NEW YORK FIRE DEPARTMENT WITH WHOM WE FIRST BECAME ACQUAINTED DURING THE PRODUCTION OF GIORGIA FIORIO'S BOOK, *AMERICAN FIREMEN*, AND WHO LOST TWO SONS—AN NYPD EMER-GENCY SERVICES DETECTIVE AND A FIRE-FIGHTER—ON SEPTEMBER 11. HIS COURAGE AND FRIENDSHIP SERVED AS AN INSPI-RATION THROUGHOUT THIS PROJECT.

LASTLY, WE WISH TO ACKNOWLEDGE THE REMARKABLE WORK OF THE TWENTY-TWO PHOTOGRAPHERS WHO GENEROUSLY CONTRIBUTED THEIR IMAGES TO THIS BOOK, AND TO HISTORY:

JANE EVELYN ATWOOD, ZANA BRISKI, DAVID BURNETT, ADGER W. COWANS, DEBORAH EDELSTEIN, CHUCK FISHMAN, FRANK FOURNIER, FRED GEORGE, GIAN-FRANCO GORGONI, LORI GRINKER, HALE GURLAND, SEAN HEMMERLE, KENNETH JARECKE, PETER B. KAPLAN, JAMES KEYSER, ANNIE LEIBOVITZ, VINCENT LOPRETO, TIM MAPP, DILIP MEHTA, ALON REININGER, FUYONG ZHANG, AND TIM ZIELENBACH.

THE EDITOR

CONTACT PRESS IMAGES, THE INTER-
NATIONAL PICTURE AGENCY, WAS CO-
FOUNDED IN NEW YORK IN 1976 BY
FRENCH-BRITISH JOURNALIST AND EDITOR
ROBERT PLEDGE AND AMERICAN PHOTO-
JOURNALIST DAVID BURNETT. THE PURPOSE
OF THE AGENCY WAS TO FACILITATE THE
INDEPENDENT PRODUCTION OF IN-DEPTH
DOCUMENTARY ESSAYS, AND TO DEVELOP
A HUMANIST PHOTOGRAPHY ATTUNED TO
MAJOR INTERNATIONAL ISSUES AND
SOCIAL CURRENTS.

CONTACT, WHICH IN ITS EARLY YEARS
TRAINED ITS COLLECTIVE LENS ON THE LIT-
TLE-KNOWN DISEASE, AIDS, HAS LONG
SPECIALIZED IN LONG-TERM PROJECTS—
POLITICAL, RELIGIOUS, AND HUMAN RIGHTS
ISSUES—THAT OFTEN TAKE PHOTOGRA-
PHERS YEARS TO COMPLETE. BRINGING
TOGETHER MEN AND WOMEN OF DIVERSE
BACKGROUNDS AND NATIONALITIES, THE
KEY TO ITS SINGULARITY AND STRENGTH,
THE AGENCY HAS CONCEIVED AND
PRODUCED EXHIBITIONS, MONOGRAPHS,
CATALOGUES, AND MANY INDIVIDUAL
AND COLLECTIVE WORKS FOR MORE THAN
A QUARTER OF A CENTURY.